The Reactor

The Reactor
A book about grief and repair

Nick Blackburn

faber

First published in 2022
by Faber & Faber Limited
Bloomsbury House
74–77 Great Russell Street
London WC1B 3DA

Typeset by Faber & Faber Limited
Printed and bound by CPI Group (UK) Ltd, Croydon, CRO 4YY

A CIP record for this book
is available from the British Library

ISBN 978-0-571-36774-0

MIX
Paper from
responsible sources
FSC
www.fsc.org FSC® C171272

10 9 8 7 6 5 4 3 2 1

I don't know what to tell you about. Death or love?
Or is it the same thing. What should I tell you about?

Lyudmilla Ignatenko, *Chernobyl Prayer*

Contents

MELTDOWN 1

HEJIRA 141

DELIVERANCE 257

Acknowledgements 398

Notes 400

MELTDOWN

You have died but it's fine, Dad. It's fine, it's fine, like Helen Mirren coming down the stairs in Red – does she shoot the security guard after? It's fine, I'm sure I'm allowed. You were getting tired of the whole thing anyway. I saw you were tired: you fell asleep in your dinner.

I'm trying not to make a big fuss over it.

Soon after it happens the distances are wrong: things that were joined together come apart. Things that should not be connected have become fused. It takes time to sort out. But something's also wrong with time.

Denise Riley on the death of her son, time is: without its flow.

You've been dead for two weeks but when it's dark and the bathroom door is half-closed and I need a piss, I still open the door politely. As if I might be disturbing you.

You died while I was presenting in a seminar on narcissism, like the punchline of a bad joke. My mother called saying I should come, that you were going. And the presentation was already terrible with me just reading and reading Andrea Long Chu against André Green about desire, about the idea a trans woman might actually want things. It was quite the exit: straight out of the room with my phone in my hand.

You were dead before I picked up the message.

I am thinking of a sample from Paris Is Burning that
Honey Dijon used in the runway show for Louis Vuitton
Menswear (Autumn/Winter 2017). We're not going to be
shady, just fierce. We're not going to be shady, just fierce.
The high-line of the music is like a shower of warm rain.

I'm writing this the day after Notre-Dame burned down, all over Twitter and the news. There is an outpouring of money to make repairs. One minute you're on a train looking at your phone and next thing you're crying about a cathedral.

You had the worst death imaginable, the death that most terrified me as a child, I think: loss of control. It took four nurses to hold you down because you wanted to go to the toilet, because you were holding your cock and pissing yourself, and the doctor was a prick you said and wouldn't let you go home, and my mother brought you your wedding album to remind you who you were but it was your bedside clock she said you remembered.

Since you died I've been watching bionerd23 on YouTube exploring the Exclusion Zone around Chernobyl and Pripyat in Ukraine, twenty-five years after the reactor exploded. She, bionerd23, has a very calm voice. In an interview online she quotes Marie Curie: Nothing in life is to be feared, it is only to be understood.

Marie Curie was poisoned by the thing she was trying to understand.

When I type the letters bionerd23 into the search box
on YouTube and then stop typing, a white box comes up
with the following suggestions:

bionerd23 dead
bionerd23 cancer
bionerd23 hospital
bionerd23 chernobyl
bionerd23 apple
bionerd23 claw
bionerd23 dead 2019
bionerd23 basement
bionerd23 fuel

She's alive though, as far as I'm aware.

I think she's OK.

In the days after you died, Dad, I watched bionerd23
on YouTube climb the Duga-3 radar array. There she is,
standing high up above the forest near the power plant,
wondering if the militiamen can see her. People have
been scavenging the Duga arrays for metal and bits of
it are lying on the ground. In another video I watch her
take home tiny crystals of uranium left over from a
pitchblende mine. She films them glowing green in the
dark.

On YouTube we are walking along a train track, along what's left of a train track, and the ground is made of stones. To the left of the train track there are young fir trees and to the right of the track are young birch trees. A man is walking ahead down the middle of the train track and bionerd23 says the man is Ukrainian personnel and has had to be blurred out of the video. As we walk, there is the crunching of stones and the scene widens and we see now that the ground is stones because there is more than one train track in amongst the young trees and this is because since the reactor exploded the forest has been encroaching discreetly, blurring out the rails.

I'm reading this over and as I'm reading, Clare Torry is wailing her part of The Great Gig in the Sky on Pink Floyd's The Dark Side of the Moon, wailing high up there, wailing and wailing. It's such a beautiful song.

I don't know if you'd like this song, Dad. I know it's an odd thing to play at a funeral, but I'm going to sit here in bed and imagine for a minute that we're having a funeral and this song is playing. It's night-time here, Dad. You've been dead for a year and a half.

The Great Gig in the Sky begins with Gerry O'Driscoll, the Abbey Road doorman, talking calmly, saying he has no fear of death, why should he and a piano takes over and there is guitar and percussion and the wailing starts.

I'm crying a bit writing this, Dad. I'm in bed with my laptop and I've got both arms stretched right out above my head and the second knuckle of my right hand is in contact with the wall and Clare Torry is singing ow and oh high up there and it's brilliant. The song is in the middle of the album, not at the end.

Wooooah! Oooaw! Ooooweeeeeeeeeeeh!
Aaaaaaaaaaaah! Oooohwaaaaaaaeeeeee! Aaaaaaaaah!
Waaaaaaaah! Ahhhiiiiiiiiiiiy. Owwwwwwwwwwww.
Aaaaaah. Aaaaaaaaaaaaaaaaah! AAAAAHHHHHH!
AAAAAAAHHHHHH! Ahhhhh! Ahhhhh! Ahhhhh!
Aahhhhhhhhhh!

Ahhhhhhhhh! AAAH!
WAAAAAAAH! WAAAAAAAH! AAAAAAAAH!
AAAAAAAAAHHHHHHH! AHHHHHHHH! Aaahhh!
Ooohhh!

Booooooooooooh! Oo-oooo! o-ooo!

Awwwwww, haaaaaaaaaa, ahhh, haaaa, waaaaaaa,
eeeeeeeeh, ehhh. Ah . . . ha . . . haaaaaaaaaaaaaa.

Aaaaaa . . . ohhhh . . . OHHHH . . . ohhhhh, oh oh oh.
Ooooooo. Hoooo – ho-oooo – waaaaaaa.

Oh. Oh. OH! Aaaaaaaaa. Laaaaaaa. Haaaaaaa.
AH-AH-AH. Oh! Wooah. Oh. Ah. Ahh. Waaa. Ha.

Listening to Julie Walters singing A Modern Romance
on the drive home one night I have to pull over and then
for five minutes I am howling and sobbing in the car
next to a bus stop. I find myself thinking, Oh this must
be because of you being dead, and I find this quite funny
so I'm laughing and then I am howling again; it feels like
the nightmares I had when I was small and I couldn't
make sense of the chaos of things.

I'm remembering my father let us dunk his head under the water, me and a friend. He was so much larger than we were, it was exciting. I find I'm regretting it now – like it's tangled with everything else. He just let us sink him under the water.

I remember once, my mother telling me after school that morning my father had thrown his cereal on the floor because he couldn't take it any more, a point when he was very depressed.

I liked cereal very much and it disturbed me, the idea of the mess on the carpet. He needed to put the feelings into something, I am thinking now, he wanted to watch something spill.

The first verse of A Modern Romance goes like this:

She's up in her bedroom, drying her hair. She calls to her mother: what should she wear? Not that it matters at all in the end, it's only a drink with a friend of a friend. It's not a romance.

It's such a simple song; why does it make me cry so much?

I think the music and the lyrics of A Modern Romance were written by Victoria Wood, who died of cancer two years before my father, on 20 April 2016, six days before the thirtieth anniversary of the Chernobyl disaster. Wood was born not far from here, in Prestwich to the north of Manchester and she met Julie Walters at Manchester Polytechnic a few years after my parents got married. I can't do Walters' delivery of the song justice by writing it down. It's 1992, she's got big hair and she's sitting on a white stool in a purple jacket against a pink background. There is something about the way she looks when she's looking straight into the camera. Now and again we go to a mid-shot and there the shadow of the microphone stretches black across her left breast. When the internet is gone or YouTube isn't free any more it will be impossible to find all of this. A writer I know says I'm wrong, that there will be a compound, a place we can go and see. I'm not sure.

The historian Timothy Snyder says there is something to be mindful of about celebrating anniversaries: it disrupts the flow of time. Orient things around a particular date, he says, and you are framing a view of the world.

Julie Walters sings: She's bought this mascara, a purply blue. She's not sure it suits her, what can you do? It's only a wine bar, it's only a drink; supposing he likes her, well whadda you think? A modern romance.

My parents met at a rugby club dance in Sale in the 1960s, not at a wine bar. They were teenagers then and they got married in August 1969. My father had his first breakdown a few years later when he was sitting his accountancy exams. He had several courses of electroconvulsive therapy and finally settled on the mood-stabiliser lithium in the nineties, which made him a lot easier to live with. It may have played its part in the organ failure that killed him, but he'd had heart problems before then, too, which limited the options for treatment. I'm not sure if the song makes me cry because it's about my life or theirs.

Writing to his fiancée Fanny Brawne in February 1820, John Keats says he's got blackcurrant jelly on his friend Brown's copy of Ben Jonson: I have lick'd it but it remains very purplue.

Keats is terribly ill around this time. Days earlier he suffered a major haemorrhage: so violent a rush of blood came to my Lungs that I felt nearly suffocated. He dies of tuberculosis the following winter.

Keats writes: I did not know whether to say purple or blue, so in the mixture of the thought wrote purple which may be an excellent name for a colour made up of those two, and would suit well to start next spring. Be very careful of open doors and windows and going without your duffle grey. God bless you Love!

I was wearing daisies and pigtails, my mother says, and a black hat and a black crocheted dress. Big fabric daisy earrings, she tells me, the hat was like this. My mother gets a pencil and she sketches the hat for me on a scrap of paper in the kitchen, a tall hat like Sugarloaf Mountain in stripes of black and white and to the right of it she draws a daisy with five petals. White knee socks and white shoes I would think, she says. Like Cathy McGowan on Ready Steady Go! I must have stuck out like a sore thumb.

He said he was Australian and could play guitar; he was neither – a guitar player nor an Australian. It failed to dawn on him he didn't have an Australian accent, my mother says, about meeting my father. I should have known then.

Crying in group supervision because in that moment
I knew I trained to be a therapist so I could make you
better and I wasn't there when you died. Because I didn't
make anything better, at any point. Because we failed
each other. Because I failed you. I failed you and I am
so sorry, Dad, and I miss you and I've missed you for a
while, I guess. When did all this begin?

Writing next in a list of things without numbers, I write down the lyrics to the chorus to The Air That I Breathe by the Hollies.

Reading them back and thinking of Eric Garner, held down by the police, saying: I can't breathe, eleven times, lying face down on the sidewalk at 202 Bay Street, Staten Island in the City of New York.

Writing next in a list without numbers I write:

Joyful things are: clouds, steam, pervasive smells of all kinds, Russia, jets of things, spines, cardboard, insect colonies, felt roofs, the weight of my boyfriend sleeping on my chest, 11.47 p.m. at the party when he falls asleep and no one else is tired. Sometimes.

In opposition to the body's desire to keep its own house, one finds oneself on the open ward; in opposition to living, one feels the body's operations of containment (even temperature, lack of tremor, inability to urinate) breaking down. And one ceases to find oneself at all. One dances.

What did I mean by this: One dances?

That last page was the first thing I wrote on my phone the afternoon my father died, in the small office at Macclesfield Hospital while my mother signed the papers. We were given his things in a clear plastic bag and we were given back the white plastic supermarket bag my mother used to bring him his pyjamas and a towel.

I think I am thinking of The Seventh Seal. I am thinking of that line of people holding hands along the brow of the hill at the end, black figures against a white sky. I am thinking of my father's madness, struggling on the ward. I am thinking of the dance of death.

One dances. How can you not?

In his book Attention and Interpretation, Wilfred Bion describes qualities necessary in the psychoanalyst, who must seek to work, he says, without memory or desire. He quotes a letter by John Keats:

I had not a dispute but a disquisition with Dilke, on various subjects; several things dovetailed in my mind, and at once it struck me, what quality went to form a Man of Achievement, especially in Literature and which Shakespeare possessed so enormously – I mean Negative Capability, that is when a man is capable of being in uncertainties, Mysteries, doubts, without any irritable reaching after fact and reason.

I find that last phrase irritates me, though; do you?

I know I shouldn't get annoyed.

I don't know who is I and I don't know who is you.

I want to keep us separate, myself and my father; I think we must get muddled in my head. It's not easy to keep hold of the ways in which another person really is different, unknown. I think until recently I found relationships difficult because when I'd been with someone for a while I felt like we were merging into one another, fighting for air.

At the same time I know I have the capacity to be a loner, watching from a distance and that this is something social media has encouraged. Writing about people I feel connected to I want to write: my friend, but then I remember: I've never met this person; I haven't seen them for years.

Writing about myself in the past is also a confusing experience, sometimes writing you instead of I like I'm protecting myself; writing to future me, for company: Hello you.

Here's where I am, I guess, on this strange journey of grief, unsure of myself, in the mood for strong forces. Looking for a river I can follow to the sea.

It is April again and you are on the night bus, rocking
on its long way towards Mortlake; a year later on its
long way rocking towards the heath at Putney and the
terminus at the Green Man where a gallows once stood
and while you are sitting, rocking on the bus, alone on
the way back from a nightclub; time and again you feel
yourself coming up against the edge of something and
you want to write, years later still sitting in bed in your
room opposite the room that is your father's room,
though he has been dead for three months, you want to
write, thirty-two years after the explosions in the Soviet
Union in 1986: this feeling's like the Pripyat river, the
river that supplied the coolant for the four reactors at
Chernobyl. The people watched the power station burn
from the bridge across the railway near the river and
it was beautiful as it burned; fabulous colours like the
Northern Lights, and the people weren't afraid because
no one had told them that what they were looking at
was death and that it was too late and that everything
was over and that days from now a process would begin
where men arrived with bulldozers and masks and the
earth would be buried in the earth.

There was no funeral.

Your father's ashes are sitting in the bottom of his wardrobe in a green plastic container and it is a nice day. It is warm outside and plants are expanding towards each other in the flowerbed your mother has constructed in the garden. There are catfish in the river at Pripyat now like there always have been, you wouldn't die if you ate one. Moss and wild mushrooms in the Red Forest absorb the most radiation; even thirty years after Chernobyl, wild boar that eat mushrooms in the forests of Germany may be too contaminated for restaurant use. An apple won't do you much harm.

Take a Gamma-Scout into his bedroom now or in the middle of the night when you're afraid and it will register about 0.251 microsieverts per hour.

Which is completely normal.

Julie Walters sings: All through the service she thinks of the fuss if she walked down the aisle and just got on a bus. A modern romance.

I am thirty-six years old.

I was four years and about a month old on the night when the fourth reactor at Chernobyl exploded, on 25 April 1986.

I remember panic-bought powdered milk on the top shelf of the cupboard in big round tins, but not that it was panic-bought.

For my third birthday I remember a blue cake, with a foil trim and a yellow plastic aeroplane on top.

My father died a few weeks before his birthday, about a month before mine. He would have been a little older than I am now when the reactor caught fire, about four years older.

I can't remember how old he would have been, or the date of his birthday without having to check.

My father was born in 1946.

That was after the war ended. That was after America dropped two nuclear bombs on the cities of Hiroshima and Nagasaki.

I'm thinking of those lyrics in the Smiths song, Ask. This binary opposition between love and nuclear war, like it's got to be one thing or the other. Two things we go to, I suppose, out of this strange curiosity for oblivion.

When did we become unable to talk about grief?

We are in the forest now. There is the sound of breathing on the video and the sound of boots crunching on the forest floor. The camera is jerking left and right and up and down; flashes of metal and wood on the floor. There is something made of round discs like part of a power line and there are old posts and oblong metal shapes and there are trunks of felled trees. The Ukrainian personnel man is still there and now and then the space around him comes into frame as a round and roughly pixelated cloud.

Now we are looking at the back end of a train carriage, blue-black, and above and below the door there is the purple-brown of rust. In front of the carriage there is a mess of wrecked metal, round pieces like springs and long struts jumbled together in a foam of white sand. Bionerd23 explains this is a classic metallist camp struck by those who go into the zone to scavenge metal, especially copper from cables. As we go closer to the train car we see the light is bright inside, and outside there are green leaves on trees. There are the ruined seats and there is the lining of the ceiling and the walls crumpled in grey ruins on the floor like ash, like there has been a flood or an explosion. To the left, in the frame of a ruined seat stands a bunch of bright-green empty plastic sleeves, their cables missing, like a headless bunch of flowers.

I am thinking about John Berger, writing about paintings in the Chauvet cave in southern France, which I put into an essay about psychoanalysis for my training the year after my father died.

Berger writes:

On a rock in front of me a cluster of red squarish dots. The freshness of the red is startling. As present and immediate as a smell, or as the colour of flowers on a June evening when the sun is going down.

In the essay I wrote:

In an extraordinary essay on the paintings of the Chauvet cave in south-eastern France, where animals, often in movement, appear out of lines, dots, traces of fingers and hands and the natural contours and pigments of the cave wall, John Berger writes, Cro-Magnon painting did not respect borders. It flows where it has to, deposits, overlaps, submerges images already there, and it continually changes the scale of what it carries.

There is an echo in this of Bacon's most famous description of the relationship between form and representation, in his review of an exhibition by fellow-artist Matthew Smith.

Francis Bacon writes, Here the brush-stroke creates the form and does not merely fill it in. Here the artist is constantly implicated in the artwork, remaking it from moment to moment, with each movement of the brush. Bacon uses two words, mysterious and continuous, for the artist's struggle to make impactful use of what he sees taking place on the canvas: mysterious because the very substance of the paint, when used in this way, can make such a direct assault upon the nervous system; continuous because the medium is so fluid and subtle that every change that is made loses what is already there in the hope of making a fresh gain.

That's a thing we are doing, I think, when we are doing psychoanalysis: where each advance is folded back into the session, even as the words of the therapist are folded back into the illness. Working in this way upon the reactor, we can do so only from the inside. It is as if we were talking in a dream.

On YouTube we are listening to Carl Willis talking in a
wide orange hard hat almost half the width of his head
again, and Carl is pointing to a laminated wall map of
the original four Chernobyl reactors. Carl says: We're all
dressed now to go into the Obyekt Ukrytiye, the Shelter
Object, we're going from SP 1430, walk down this road
here, enter the er, the er, local zone and Shelter Object,
down here, east end. Bionerd23 says: Hell yeah, let's go.
We are outside now, past the old sarcophagus with the
chimney in the background and in front of it there is a
small crane, and the ground is made up of smooth grey
pebbles like the bed of a river. The staircase inside the
Shelter Object is slightly wet and there is shouting in
Russian and after that we hear a thin door shut.

We are walking down a golden corridor of closely
corrugated yellow metal installed after the explosions,
finely grooved like the between of two layers of
cardboard. To our right, the light is coming in through
three large panes of what seem like frosted glass. Ahead
and to the right will be reactors one and two and then
reactor three and beyond the chimney is reactor four.
Now the floor is highly polished tessellated tiles of white
and grey, and in the space of each repeating lattice of
white tiles there is set a grey star.

The Chernobyl control rooms have such style: the floors
are grey and made of polished crazy-paving marble or
slate; there are grey, deep consoles edged with yellow,
high grey panels framed by burnt orange on the walls,
full of strips and square controls, silver and yellow and
white and dark green. To the far left on a console at waist
height are the two halves of a circle of big square buttons
and then small round lights housed in metal rings for the
fuel channels for reactor two: red, green and yellow, white
and blue, like a child's drawing of a fruit tree.

A week after he died I couldn't get to sleep, I needed to get out. I needed to go out and be with strangers and get drunk and be invisible and be out on the road near the river in the night.

Next week it will be October. You are wondering why
(you are teaching, your young student is writing) you
wanted to talk about radiation. The leaves are falling.
You remember how fascinated you were. You feel that
you will not be able to explain. That there was a world of
sensation which lay open before you and is now closed.
When a reactor explodes the most reactive elements have
the shortest half-lives.

When you were quite young, one summer you were in
your holiday bedroom and you had a very clear picture
in your mind's eye of a door standing open and that if
you could only [] through it then anything would
be possible, and you did not go through it and the door
closed.

You read through this again one day.

You'd left out the word go.

But for moments you were there, on your own in your
holiday room, with the light coming through that
doorway standing open [] in your head.

Eight years before your father died you wrote a story.

Hannah, you wrote, was very lonely after her mother died. She used to go to bars, and drink rosé wine late into the night, and talk to women who did not want to sleep with her and did not want to look at photos of her beautiful dogs, or her children.

Every day she would go to work. Hannah was a nuclear technician. Hannah sat at her desk and looked, and there were all the little lights that told her about the reactor at Byrne Sands, and how it was feeling today and she would think about her dogs and how in her kitchen gaps were opening up between the interlocking veneer segments, blue-grey making up the floor. Often, at night, she would dream she was walking down the dry bed of a river, foot after foot, among the dry stones.

At 3.35 a.m., on Tuesday 11 March, a fault developed
with the cooling system in reactor four. At 3.42 a.m.
the water protecting the core of the reactor boiled away,
leading to a massive explosion.

Hannah is walking down a corridor at work as 85 petabecquerels per m^2 of caesium-137 are spreading out through the hole in the reactor building, across the south of England and Western Europe. Employees who nine hours ago had brushed their teeth as evening came on have dropped cups of coffee and left behind shoes and data printouts. People are screaming.

Hannah goes to the end of the corridor, and into the office where her boss works. She lies on the ground and she feels the carpet on the backs of her calves and beneath the palms of her hands. And she feels – completely – OK.

Which is to say that the workings of grief are unconscious, invisible. Like radiation.

It was a surprise, after your father died. You hadn't
felt like this before. It was as if the feeling came from
somewhere else. Coming back to your training group
of psychoanalysts – there is a conference of different
organisations and the people you know are sitting
as part of concentric circles with trainees from other
organisations – for the first time, people touch you, you
are being hugged, your hand is held.

One of your colleagues is pregnant and you think: Is that what it is like to be grieving? As if somehow you and she might be photograph and negative: a body that is not just one body, a body people want to touch and are afraid of touching. She is with child, and you are without your father, carrying him about inside.

Coming back to read this months later, you think: Grief makes people very self-centred, doesn't it?

We are walking down a ruined staircase, down into the basement of Hospital 126, where the first victims of Chernobyl were brought, coming to a corner square before the stairs turn 90 degrees and at the bottom of the screen we see the Gamma-Scout, yellow inside a clear plastic bag. Further down the stairs we turn the corner and there is someone with a head-torch and a mask and white plastic gloves. We are walking down a corridor, nearly a tunnel, green on the night-vision camera, following a thick ventilation pipe covered in tape like an umbilical cord down the centre of the ceiling. Now the floor is all slippers and clothing and something metal crushed flat like a tin. The Gamma-Scout ticks away and when you pause the video you can hear your mother snoring in the next room.

Sleeping with the blinds half-open between morning and afternoon you dream about young men, as if you were dreaming a film.

A group of teenagers are realising a game they have been playing has been networking them together, update by update, and they are beginning to know one another's minds. I know what you're feeling. It comes as a shock.

Later that day, on the train south again, you think about how this is what becoming an emotional adult, a sexual adult, is really about. And the alarm or the violence that comes with the shock.

Finding yourself inside another. Finding another is inside you. Pregnancy, grief and sex.

How did you get in here?

I've got to get out.

So, when you started therapy, when things started to take hold, you dreamed of putting your fingers into the boiler flue; the sensation of the greasy soot on your fingers. You dreamed of escaping up out of a mine into the desert, climbing up on to a fridge to get out into the light.

You try to recollect the balance of your voice, on the phone to your patient before their final session, a session they themselves may have cancelled, at eight thirty that morning when you had decided with your mother he would have to go to hospital, that perhaps it was a stroke.

I'm so sorry, there has been an emergency. I know it's bad timing, I will be in touch.

The reasonable, calm reply.

An offer to reschedule, never taken up.

Arriving at the hospital, you are looking at this now both backwards and forwards through time.

This man has less than a hundred hours to live, you write into your phone. This man when you test him will forget the name of the prime minister and the day of the week; four nurses will be required unsuccessfully to restrain this man. You are writing this on the Northern Line, in the first heat of August in the hottest summer since 1976, in the hottest summer for one hundred thousand million years and all the citizens are dead, all the forests are on fire, all the seas are boiling dry, as Donald John Trump, the forty-fifth president of the United States on national television (fake news) hoists a child into his open mouth and swallows it whole, as in the cooling pond a great grey fish with the face of a man rises to the surface and sinks back down and you sit here on the burning Tube, thinking of hospitals, thinking of your father, as the train pulls into Tufnell Park.

This murderous heat.

And that night, is that the more likely time for you
to write it down; a time, several drinks down, most of
a bottle of rosé (there were two bottles, between five
people) a double vodka, a double gin, less than the
military on duty at Chernobyl or more, drinking perfume
(did they? trying to control the radiation smelling of
perfume; you're drunk, you're mistaking), drinking
lighter fluid, antifreeze. Where were you?

Stalling now while writing. Swallowing the drink.

You were there when she was telling him to swallow, but this was also something you were told about, told was happening, on the phone. It is something you want to remember being told and not seeing for yourself. Your mother telling your father to swallow his food: Robin, swallow it – trying to get him to eat and losing her temper. Writing this with a sadness which hasn't left you (you can't swallow it, you think later; it won't digest), but which stays and says that really you do not want to write, do not want to bring this private grief, not yours only, into the light.

He died before eleven in the morning, no shadows on
the ward to cover your father when he was naked, as you
were told, when he was angry, when he was incontinent
– none of which you saw, thank God, none of which you
ever quite unsee. You have to be drunk to write it down,
have to avoid it, the chewing, the retching, the spitting
out, him thinking you were your uncle, oh God, his
brother-in-law, what was happening? Asking you calmly
the day before, if Edward (your cousin, a journalist in
Russia on and off, who you haven't seen for thirty years)
had left the White Sauce mix (would you mind having a
look?) in his room.

You looked.

You looked under the bedspread, down beside the bedside table, for the bowl of White Sauce mix.

Coming downstairs, saying, No, no White Sauce mix, it occurred to you to ask him: Who is Edward?

Your son, your father said.

Stephen, your analyst, the man you see out of the corner
of your eye, here you think he protects you, about the
White Sauce mix, the horror of this whole scene, you
remember him saying: Mix, yes it's a mix, it's mixed up.
You were relieved, because in your mind it's semen, it's
brain matter, it's both together where they should not go.
You are remembering your best friend who had a brain
tumour that would return, that was regrowing, of which
a consultant said to him: Like separating two kinds of
paint, we cannot, we are not able. You loved this friend,
and you wanted to say goodbye, but when the people
who loved him more, his family, said, This is our time to
say goodbye, you did not argue and you did not see him
again before he died.

For all things are interwoven and separate afresh, and all
things are mingled and all things combine, all things are
mixed and all unmixed, all things are moistened and all
things dried and all things flower and blossom in the altar
shaped like a bowl.

It is wild to be alive when your father is dead.

The glass is doing something to your eyes. Somewhere between the outside summer world and the outer glass of the train window or in the void between the inner glass and the outer glass or the void between the window and the various structures of your eyes an error has crept in and your vision is warping. Something is wrong with the glass.

As the train passes, as the landscape passes as you sit on the train, something is happening to the shapes of the trees and the dry July into August fields as you listen to music on your laptop.

Then in the morning, walking through the square, it is the same. Or something of it is there. Now you are in the carriage on the Underground train thinking: You were walking through the square feeling sad, you are still feeling sad. But up there, under the blue sky, among the trees in the square, there was a film upon things. You tried to rub it out of your eyes and there was sleep there yes, there was something to wipe away. But as you sit now underground there is still, you feel, a sense of a very light mist of dust upon things. You are still remembering, as you remembered in the square, Kafka's Before the Law; you are not sure if it is that your eyes are growing dim or if the world is getting darker. And as the Northern Line makes its crooked way up towards Archway, these thoughts sit heavily upon you, and leave upon things as then you wrote that it felt, a very light mist of dust.

Kafka's Before the Law is a peculiar story: a parable, sort of a modern fairy tale. A man (from the country, Kafka says), comes to ask to gain access to the law. There is a doorkeeper, who says he can't go through. Is it possible I will gain access later, asks the man. The doorkeeper says yes, it's possible. But not right now. The man sees that no one is really guarding the door and considers going through. The doorkeeper notices this and says, well, just to let you know, behind this door is another door, and another door, and another door yet and each door is guarded by a doorkeeper successively stronger than me.

Kafka included this story in two short collections during his life, and after his death it appeared in the published version of The Trial, where Joseph K. is the man from the country. In my first term at university, I acted in a version of The Trial (I was K.'s lawyer) originally devised by Steven Berkoff. It was my first experience of the physical theatre style that came out of Eastern Europe after the war, and seemed to me very serious and exciting.

I've read on Wikipedia that in the original version
of Before the Law, the man spends the rest of his life
bribing the doorkeeper with everything he has, which the
doorkeeper accepts without comment. In the version that
opens Berkoff's The Trial, K. simply waits. Eventually he
grows old; his eyes grow dark. He does not know if his
eyes are failing or if the world is getting darker. Seeing
he's about to die the doorkeeper comes close to him –
in one version I think he shouts in his ear. K. has been
wondering about the fact he's never seen anyone else
seeking access to the law – the doorkeeper says: There
could be no one else because the door was intended only
for you. I am now going to shut it.

It is an alarming story; there is a nightmarish quality to
it. It never occurs to the man to go home.

And on these mornings yes, the roses, the sharp unseen briars have closed their teeth around the castle. The silver birch, its movements unheard, unseen, has pushed up through the roadway over the long years without traffic and in the forest railway carriages have been stripped for resaleable metals, their insides open and seatless against the onrush of bees.

In New Zealand a girl is on holiday and she is bitten
by a shark. The doctors sew her up but the shark has
pierced the girl's bowel in several places. She will be
weird tonight, the doctors say, she'll be in shock she'll
say things, she'll be fine in the morning. The girl says: I
am burning up; the girl says: I am in so much pain. Later
in the night, waking her parents again the girl says: I'm
dying. You'll be fine in the morning, go back to bed. The
girl is vomiting brown liquid her parents think is Coca
Cola. The girl is vomiting blood and vomiting parts of her
insides and the girl's lungs are filling with liquid that as
they race to the medical place the next day will make it
increasingly hard for her to breathe.

You feel faint as you hear this on the radio, coming out of your phone, in your room, in the dark. Let it go, you say to yourself: in the morning, in the light you will have forgotten this feeling.

But then you are switching on the light, too bright, turning it off, typing in the dark about the girl, about your father, jerking out of his chair at the doctor's office the Monday evening before he died. The doctor says he's just run down, he's had an infection, he's tired.

In the silence of your room there is the roar they heard
in the control room at Chernobyl, the low roaring
boom that sounds like an earthquake that is the reactor
exploding, that is reactor number four blowing off its
concrete lid which rises up into the air and down again
as its molten contents boil through the base and the
concrete floor below, through the bottom of the plastic
container of your father's ashes and the wardrobe and the
floorboards and the ceiling and the concrete floor of the
garage, reaching downwards for the breathing soil.

On YouTube, we pass huge wooden beams of debris,
too big for fences. A map appears on top of the image
hand-drawn in colouring pencil and marker pen and
highlighter and we see the railway line highlighted in
pink, where there is Pripyat to the north and there is
the power plant to the south, close by the rails. We are
at Yaniv train station, the main station of Pripyat and
the closest to Chernobyl town (not very close). Before
1986, the line was served by the Moscow–Khmelnytskyi
express service and further on from Yaniv out to the west
there is the station at Ovruch where Primo Levi stopped
on his journey from the Auschwitz concentration camp
to his home in Turin. Wikipedia says the card game Yaniv
is considered a backpackers' game in Israel, and is popular
among soldiers and young people returning from long
trips.

There are maps in the storybooks you loved as a child. Perhaps your story should have maps too.

The Exclusion Zone, the Chernobyl Nuclear Power Plant Zone of Alienation, initially seems huge to you on the map. You struggle to place Pripyat on Google Maps, which you realise looks to you upside down. You're used to seeing Chernobyl above Pripyat, whereas in fact Pripyat lies to the north as the plume of Permanently Confiscated areas (40 curies per square kilometre of caesium-137), Permanent Exclusion, and Permanent Control (15–40 curies per square kilometre), stretches north-eastward in red dots and blotches through Belarus to Krasnapolle and the border with Russia.

Radioactive atoms want to become stable again, so they release energy until they get back to a balanced state.

We call this radioactive decay.

Closer to when it happens things can be said differently. There is clarity. Now things are less clear. You noticed after three or four months a slowing down. Five months since your father died and something changes: the process of writing is harder now, and what you fear is that things can no longer be said. The currency of your pain and what sat within you quietly, the uniqueness of your loss: these values have dropped and the space they occupied has lost the hard definition of its boundaries. Writing seems unnecessary and expensive.

What did I mean here by expensive? I'm not sure it makes sense, though we do say writing is taxing. It also makes me think of the first line of Shakespeare's 129th sonnet (I don't think he numbered them all himself):

Th'expense of spirit in a waste of shame

Every Night

You are on a train listening to Phoebe Snow's cover of
Paul McCartney's Every Night and it is lifting things.
There is a wonderful turn it keeps performing between
what happens every night, with everyone else, in every
other situation, and what the singer wants to do tonight,
which is to be with the person he's singing to (she's
singing to). They want to get out of their head and this
other person is grounding somehow. You love the effect
of McCartney using the word be; not fucking or loving,
not just that: being.

One night you dreamed a bee had made its nest in the top of your head. This was a dream that when you reached the bathroom mirror still clung and left you slightly sick with fear to touch your own scalp in case of revealing the hole, disturbing the bee.

There is a buzzing as you type.

A wasp is in the room somewhere, this July evening in the room across the landing from your father's room. Inside or outside the shutters; inside the shade of the lamp.

It's really there.

You turn out the light, open the shutters and leave the room. An hour later you come back. You do not hear the buzzing again.

It is July; it is southern Spain. You are looking out over
the plain towards places whose names you don't know.
There are mountains and hidden beyond the mountains
there is Malaga and the sea. There is the high drone of
flies, like race cars. It is hot now; it is afternoon. You
have come back to sit down and to write again about
mourning and your father and about the accident at the
nuclear power plant at Chernobyl, which you tried to
do earlier. You looked then at the beauty of the valley
laid out before you and at the logic, unknown to you, of
its olive trees and green crops and yellow grass and you
couldn't write because you wanted to have the names of
all the hills you saw. You wanted the hills to have names.
You looked on Google Maps and there wasn't a name
for that hill, or for that hill off to the right which looks
to you now like a mountain with a bite out of it. And
you stopped writing in the face of the namelessness of
everything you saw and of your ignorance and your need
to know things quickly and you went inside.

Now you put on the black Rick Owens hoodie that comes down to your knees and your high-tops, gold like the golden corridor at Chernobyl, and you go outside. This is my mourning dress, you say, joking, I am in mourning for this vile holiday, and the others laugh. You take off your high-tops and your mourning dress and now you are in cold, clear water. A wasp is struggling on the surface of the pool. Dip beneath the water and there is a cracking in your ears. Does this come to you through the water or from inside your head?

In your room there is a lizard, there is a white wall and the shutters are closed against the heat of the day. A lizard crawls strangely up a white wall and the lizard is lost among the young thin trunks of trees that make up the ceiling and you think about when the orange trunks were trees that stood amongst this July heat: orange against the orange earth in the heat of the day and brown against the brown earth of evening and blue and charged with heat against the blue earth, as darkness fell at night.

When you are near water, when there is water in the air, when what is needed in the air is water, you find yourself thinking of the people who were fishing that night on the cooling pond at Chernobyl, the night the reactor exploded.

Those people fishing on the pond at Chernobyl that night have not been named among the dead. Could they have survived? Or is this fact you remember simply a ghost, someone's exaggeration that has found its way into the history of the accident? When you imagine this place you think of it as hot, but summer mornings are cold. There were catfish in the cooling pond; there are catfish there now, much larger than they would have been not because of the radiation, but from the absence of people fishing. Nature does better without our help.

You are in the last days of September, on a train without
plugs. You are headed south. It is a sharp, clear day and
you are thinking about a statue called B of the Bang.
In your mind this statue is smaller than it was. It was
the tallest statue in the UK for many years, designed
by Thomas Heatherwick to commemorate the 2002
Commonwealth Games outside the City of Manchester
Stadium. The statue was taller than the Leaning Tower of
Pisa and this radiating, sea-urchin metal render of a blast
stretched out impossibly, unsupported, into space. Its
name comes from Jamaican-born British sprinter Linford
Christie talking about the point he'd start running: not
at the bang but the B of the bang. Six days before the
launch, the tip of one of the spikes detached and fell to
the ground. By 2009 the council had decided B of the
Bang was irreparably unsafe and the arms were put into
storage. The core was sold for scrap in the year of the
London Olympics for £17,000.

It the city of your mind, B of the Bang is further west than it was, connected with the university somehow, or on the border of Moss Side.

In the early-morning, street-lit darkness of your memory, you have stopped in your car. Now you are driving on the carriageway, catching sight of it from a distance in the traffic's movement. Now it is night-time and there is a bridge and bollards halting the road, and the road carries on behind the bollards and B of the Bang is there amongst the bollards and the roads.

In sodium streetlight you sit alone in your car, and giant and still in front of you there is B of the Bang. And this, you decide on the train and the last 2 per cent of battery left for writing on your phone, must be how to begin the story of how things exploded.

You are sitting alone in the bright light of Victoria
Station on a high balcony outside a Wetherspoons,
thinking about your father's death and about the nuclear
accident at Chernobyl.

In forty-five minutes you will get the train to Eltham,
where Henry VIII hunted deer and wild boar, and
you will talk to your supervisor about your patients.
You wonder why it is you don't want to write about
Chernobyl, which feels like it has all been set down
before, and about the week before your father died or
about his life, which has not. You are thinking of a sonnet
by Thomas Wyatt, about power and desire in the lethal
environment of Henry's court, about a deer you mustn't
hunt. *Noli me tangere*, for Caesar's I am, and wild for to
hold, though I seem tame.

Reading this back you think, Oh, Caesar's I am.

Caesium.

Caesium-137 is one of the more common fission products from the decay of uranium-235. It has a half-life of about thirty years. It is fourteen hundred times less active than iodine-131, which did the most damage to people in the immediate aftermath of Chernobyl but has a half-life of only eight days.

And wild for to hold, though I seem tame.

Your mind moves to the red forest and the crumbling dachas and to catfish fattening in still waters and to the roads in Pripyat as the trees grow through them. You think about fertility in a place that rejects humanity, woodlice teeming in the walls. There is the produce that mustn't be sold; there is the earth that must be buried in the earth. Signs on the occupied dwellings in Chernobyl city: the owner of this house lives here. You think about the journey perhaps you have to take in writing this book to the Red Forest and you think about the journey that perhaps you have to take, before the close of the year, within a few weeks, to the coast in North Wales, where you will go alone and you will scatter the ashes of your father on to the margin of the sea.

Nuclear.

Unclear.

You are sitting alone in your consulting room after the
night you thought you would be able to write about
the accident. You had a can of Red Bull thinking the
writing would come and you fell asleep. Before you fell
asleep, you read about the details of the accident again,
and you felt again the feeling the accident gives you:
a sick feeling, as very complicated science meets very
complicated politics and human relations, the workings
of the Communist state in 1986 and its targets for power
production. An experiment in low-power operation has
been ordered, a process that will investigate a further
safety measure the reactor was designed to have which
has not yet been brought online. Your mind hurries
to a phrase about the explosions: until the reactor
disassembled itself.

In another way perhaps you think the physical process is not that complicated. But there were so many teams of people, as morning shift passed things on to evening shift and then night shift before the experiment was ready to begin, that the shape of something somehow became lost. It is not clear who pressed the button to SCRAM the reactor. It is not clear if it was pressed at all, though that is what the remote computer records as having happened.

I'm using the word SCRAM because when you look it up it's so weird and inconclusive as to what it means. It's the AZ-5 button in Soviet reactors (*Avarinaya Zashchita 5-y kategorii*, the fifth level of emergency protection), but it's the equivalent of a button on American reactors with the word SCRAM written on it and a plastic cover so no one presses it by mistake. SCR also contains the initial letters of the words safety control rod, but all the definitions for the acronym SCRAM seem to have come later, as if to cover over the idea that's what you want to do in an emergency shutdown: to scram, to get out of there as fast as your legs will carry you.

Advertising on the Tube foretelling Christmas.

Fun unusual presents.

You remember a moment in Doctor Who that disturbed you as a child. A drilling team have made a hole deep into the crust of the earth and slime is coming out and turning people into monsters. Something deep inside the earth is leaking out.

There is an encounter with several of these monsters close to the drill head, still wearing their lab coats. They drag one of the scientists to the area of the drill and bring him into contact with the slime.

There is the moment you remember in Horror of Fang Rock, where a man meets a creature in a darkened corridor. Is it familiar to him? You do not remember seeing the encounter, just the sharply rising panic of the man who says: Oh don't do that! Don't do that!

But something gets out of control. Something has been started between these men and there is horror.

Until the reactor disassembled itself.

You want to write about steam voids, not about the whole event.

At this point, partway into a session, you say to your patient (your patient is waking up with a dead arm), you say there is something dead about the place; your patient says: What time is it?

Until the reactor disassembled itself.

You step out of the clinic into bright autumn sunlight and you close your eyes. The sounds of the leaves are sharp and bright and the feeling of the wind is cold and hot and you know that somewhere beyond the buildings of London and the Thames and the Thames Barrier and the Dartford Crossing and Grays and Gravesend and Cliffe Pools and Canvey and St Mary Hoo there is the wild glittering sea. A blind man with a cane bumps against the bonnet of a parked Ocado delivery truck and everywhere there are builders and construction and bottles are dropping into recycling and there are distant sirens. They say the oceans are filling up with plastic. They say global temperatures are rising fast, too fast, faster than they thought. Five people are arrested for burning on Bonfire Night a cardboard effigy of Grenfell Tower and for laughing but no one is arrested for murder. What time is it? Certainly it has always already been too late.

Some elements are unstable. You are sitting typing on
the train and you want to write clearly about why this is
and it is not straightforward. The nucleus of every atom
except atoms of hydrogen needs a neutron to keep it
stable. N is for neutron, N is for nucleus. I is for isotope.
Things are happier in opposing pairs. Uranium atoms are
dense, denser than lead. Uranium atoms exist in forms
that have different numbers of neutrons in the nucleus.
These isotopes occur in nature: less than 1 per cent of the
uranium that exists now has 143 neutrons instead of 146.
Uranium has 92 protons, making up uranium-235 and
uranium-238.

The slow decay of uranium is the main source of heat inside the earth.

In most nuclear reactors, pellets of uranium dioxide
are encased in fuel rods. When uranium-235 captures a
moving neutron it briefly turns into uranium-236. About
82 per cent of the time what happens then is the atom
splits, forming two new elements, often also unstable,
one usually much heavier than the other. Two or three
neutrons are thrown off which can split other atoms
which also release neutrons which can split other atoms;
this escalating process is called a chain reaction. The fuel
rods are surrounded by a moderator, which can be either
a solid or a liquid: a substance which is good at slowing
down the neutrons that pass through it, bouncing off its
atoms without being absorbed, which makes a neutron
more likely to cause further splits. Control rods, made of
a substance good at absorbing neutrons without splitting
(like boron), slow the chain reaction down. The splits
release a lot of heat. The reaction heats water to create
steam, driving turbines, generating power.

The driver is angry and has stopped the train. The driver is complaining about the person who has jammed the doors open. The train will not move until the person has folded their bicycle. The person must get off the train and display their folded bicycle.

I do not understand why uranium-235 spits out the neutron. I think it is something to do with the binding force and with the odd number of neutrons in the nucleus. Things are happier in opposing pairs.

In the time it has taken you to get from Brixton to Archway the weather has changed. A storm-front has come over Highgate Hill and the sky is emptying itself. After the session, the weather has changed again. A pressure vortex is over the Atlantic. There is so much weather today.

Next week you go to New York and you are trying to fit in all of your clients before that. Seven appointments over eleven hours north and south and north again, up and down the Northern Line. Chalk Farm to Brixton to Archway to Elephant to Camden Town to Kings Cross to Elephant again. You are keeping the reactor going. You are finding, too, these underground journeys are good times for you to write. By the time of your exit from Elephant a woozy tiredness sits upon you and walking through the station is like walking through oil. You look down at the shoes of other passengers. You wonder: How do people keep such clean shoes?

Tube hoardings say:

Zzing is Believing.

A Refreshing Natural Burst Of Energy.

a bruise

You get a Diet Coke from the shed by the railway bridge opposite the Strata building. Something seems to be happening in your left ear where a vacuum slowly fills and then forms again every few hours. Planes move between vast, white clouds. Now you are waiting for the overground to Saint Pancras and there is lots of sky: blue-white and grey, fading to yellow like a bruise. Now you are eating a biscuit guiltily under the Eurostar departure boards and a woman from a reality baking programme sits down beside you. She has done something with her hair.

There is a text from your bank: You remain in an unarranged overdraft and have been charged.

The K in RBMK reactor is for *kanalnyy*, meaning channel-type. Chernobyl's reactor had an unusual design. Eighteen fuel rods were arranged cylindrically in a carriage to make a fuel assembly. Two of these were placed end on end within a pressurised tube they called a channel. The channel was cooled by water from two loops, which was allowed to boil in the channel on its journey to the steam separators where the steam would drive the turbine. This gave the operator the ability to isolate a channel while the rest of the reactor was still working and to lift the assemblies in and out for refuelling.

Spaced out within the core, the channels were separated by graphite, neutron-slowing blocks. Other channels contained control rods, which could also be raised or lowered (mainly lowered) into place to absorb neutrons and slow the reaction. When a control rod was removed, its place was taken in the channel by a neutron-slowing, graphite rod. Above and below these rods was a 1.25-metre gap, which filled with water.

The water in the channels also acted as a neutron-absorbing material, complicating the system. As the pressurised water boiled, it created small voids of steam. Water and steam do not absorb neutrons in the same way.

During the low-power experiment which led to the explosions, almost all of the control rods had been withdrawn and the number of neutron collisions was low. This meant there was less heat, and fewer voids of steam in the core, but also that each increase in steam had a disproportionate effect on the number of reactions. More steam, less absorption, more heat, more steam. This is called a positive void coefficient.

I once saw a model of one of these reactors in an abandoned school in Belarus. It's on the teacher's desk in a physics classroom. The building's in ruins.

As the water boiled, an area of more intense reactivity developed lower down in the core. When this became dangerous, the AZ-5 SCRAM button was designed to insert the control rods as quickly as possible, moving the graphite and the gaps filled with water out of the way. It took eighteen seconds to push the control rods all the way into the core.

For the first few seconds of inserting the control rods, the rods displace water with reaction-increasing graphite. At the beginning of the emergency shutdown procedure, nearer the bottom of the core, the procedure increases the number of reactions even as it tries to slow them down.

During these few seconds, the amount of energy in the core increased until the reactor disassembled itself over the course of two explosions, the second of which lifted the two-thousand-ton concrete lid of the reactor into the air, exposing the burning core.

Now your Tube journey takes you north. Opposite you on the train a woman reads Tender Is the Night, with the book resting upon the coil of her scarf. Sometimes when you are on the Tube you have to get up and move carriages, as if you are looking for someone you might find, or as if avoiding danger. As if, two carriages down on the packed platform against the flow of commuters, someone might be able to explain.

Tube advertisements say:

Psst. Up here.

Light up your life.

Live fast drink strong.

We don't have to label the milk as mine any more.

At this point I want to insert a section where I compare my father's last few days in hospital to what happened to the reactor. Something about this would be very satisfying. The hospitals I am familiar with are large buildings, built in the 1950s, 1960s and 1970s, not unlike nuclear power stations. My father's worsening illness was also subject to the shift-work patterns of the hospital: day shift, evening and night. Then I imagine the channels and barriers in his body: absorbing and exchanging there too. There was poisoning of the system. My mother's research on the internet suggests that a problem in his parathyroid glands led to a devastating build-up of calcium in his brain and something like metabolic encephalopathy. (White Sauce mix.) There was no autopsy.

It feels important to say, though, that generalising things, or seeing what is happening as the supporting evidence for a theory, is to fall victim to the same limitation that causes a disaster. One thing is not the same as another. Thinking stops us looking.

But what do you do when looking is unbearable?

Your journey seems to be taking a long time now, as if the train is struggling uphill or time is slowing down. You haven't had lunch and at three o'clock things are threatening an explosion or a grinding to a halt. You are thinking about a song by Madness called (Waiting for) The Ghost Train, which is about apartheid, men's voices singing ooh like the whistle of the train, like ghosts with white faces. Suggs isn't fooled, he sings, he knows what he hears: it's coming.

These sudden flights and drops, this unexpected whirring into acceleration after calm. You are writing and you are aboard the ghost train, head stuffed with something, like a scarecrow, eyes sewed shut. You are thinking of your favourite phrase from Angela Carter, who writes:

She herself is a haunted house.

At the homeless hostel it is harder to concentrate. There is a radio playing somewhere or a music channel on a screen where the residents play pool and just the treble of Killer Queen is floating through the wall. You have tried to meet your patient on a different day and he is ghosting you. In the next room Freddie Mercury is singing about explosive materials, a mind-blowing experience. A man in the foyer is muttering to himself. As you pass he says, clearly, mysteriously: I can see you!

There is a pigeon by your feet as you sit on the platform at Stoke. There is the feeling of pressure, just by your temple, that says to you a spot has formed. You move your feet and you want the satisfaction of the pigeon ruffling away down the platform, being gone; you pinch your fingers and you want the satisfaction of the spot bursting, of a blockage cleared. The pigeon does not go away, and nothing bursts.

The plug for the cable for your phone has wormed its way free in your bag and you are rooting through the awful compaction of clothing and books to find it; a young woman is looking at you and smiling. She asks: Where have you been? It's where I'm going, you reply. For a few moments there you are, wishing there was something alive in the bag, a kitten or a baby, for the two of you to discuss, but not these empty clothes, your father's suit on the hanger it has been on always, taken from a regional hotel somewhere in the 1970s or 1980s. One of these hangers, perhaps now lost, you remember having a South-West London postcode.

You are thinking: There are things that don't hang around like radiation, there are things that are gone.

It is summer here. The land is fertile.

Your dad's dead and you never took a single hour to get to know him.

A memory comes to you about a night ten or fifteen years ago, when your mother and father stayed up together, when the side effects of some antibiotics had stopped her sleeping. A night they talked.

Julie Walters sings: He's stroking her hair now, he says it's like silk. She says that she's sick of smelling of milk. They're holding each other and hanging on tight; he says, Let's stick with this it has to come right. The sun hits the curtains the room's full of light. And the sun shines.

real waves

When you were twenty-one or twenty or nineteen, you
went to Australia in December and it was so beautiful,
ocean, blue sky that you felt you'd died. Your friend
taught you about real waves on the beach. You must go
under. You want to go over them but they are too high,
you mustn't. You will be swept on to the hard sand of the
beach.

hospital desks which aren't there

It is November in New York City and you are in a burger
restaurant with a friend. You drank a lot of drip coffee
in the morning and you feel like perhaps you haven't
completely adjusted to the time difference and perhaps
the coffee helps with this or perhaps it makes it worse.
You are making things up in your peripheral vision
which are demanding your attention, such as hospital
desks which aren't there. Your friend is not having a great
time in New York, this comes slowly into view out of
the periphery. Your friend is talking about the accident
at Chernobyl. Several times he says: positive void
coefficient. You say the phrase you love, you say: steam
voids.

Writing about New York the following week, in
London, in the early evening, next you think about
how perhaps you like this phrase (steam voids) because
of its contradiction: steam suggests to you a build-up
of pressure and a void is its opposite, but these exist
together. For a neutron a steam void is a place where
collisions can happen.

You are coming to the end of the period after your train
and before the time you have to get ready for your
patient: a space between two voids.

For the two people in the reactor, the steam void – the session, a place of contradictions, possibility and danger – is not a void at all.

You are on a flight with your boyfriend James, whose friend is getting married in New York. The turbulence sign has been turned on and the attendant is checking seatbelts. You are happy and you have had two glasses of wine, which the flight attendant has made seem like one more than you are allowed and so you feel special. You are in economy and so there is not much space and your boyfriend has read what you have written and has asked what you are writing, whether what you have written goes with grief or the accident at Chernobyl. Your father's sister texted you yesterday and you were supposed to remember to call her but you did not.

On the complimentary music from British Airways there is If I Needed Someone, part of a concert for George Harrison. You are going to New York and you are thinking about the Beatles in New York, and how in therapy this week you imitated Quentin Crisp's voice in the Denis Mitchell documentary where he talks about the bus journey where the Canadian or Australian or New Zealand man with the roadsweeper's hat sits down behind him and then stands behind him, gets a comb out of his pocket and starts to comb Quentin's hair. And the man who sits in the corner of your eye made you wonder about New York, about what you were saying about a new chapter of Quentin's life. You hope the flight attendant will return and bring you more alcohol and you realise that If I Needed Someone isn't playing, not because you aren't pushing the touchscreen hard enough, but because the headphones have become detached. Quentin begins by saying: Of course some of the things that have happened to me in the street are not savage, they're just sad – at least, they're sad to me; they reveal a nature more peculiar, more lonely than my own.

You want to show your boyfriend everything you've written, and also you are rather irritated because of his reading what you have written over your shoulder. If I Needed Someone. You press harder to try to get this track to play and you press the Next button which shows the other tracks and All Things Must Pass is further down and now Sarve Shaam is playing. Eric Clapton is talking about remembrance and introduces Ravi Shankar and (press) there is George Harrison. If I Needed Someone. You go to the toilet and the wall is a mirror and you are getting older.

In the soft light which is really a harsh light, you know the skin is creasing round the corner of your eyes and that in thirty years or forty years your body will be like the body of George Harrison and your body will be like the body of your father, which is to say you will be dead.

But today it is 10.30 a.m. in New York and it is 3.30 p.m. in London. You are listening to Here Comes the Sun and you are crying somewhere over the Atlantic Ocean. A man off to your right is filling out his landing card which is a requirement for entry to the United States and the man is using his phone as a torch which is going into your eyes and the ache in your right eye distracts you from crying, though you continue thinking about Here Comes the Sun, which your mother used to play in the car when you were small.

It is 10.37 a.m. in New York and you have had two glasses of wine. You will sleep soon. You press the button on the touchscreen. While My Guitar Gently Weeps.

In another YouTube video, we are walking down a light concrete road, which is narrower than the length of a man lying down. It is winter and the birch trees are bare in the distance, though between the birch trees and the horizon stands a line of evergreens, black against the white sky. There is a telephone line or a power line running down the distance of the picture on the right-hand side, parallel with the road. There is a long crack running down the road, from which additional cracks break off at right angles and to the left and right the winter straw of grass looks almost white. There are small patches of dead grass on either side of the road. They are almost white. They are grey-yellow, like frozen smoke.

Quentin says: And as the bus swayed on its journey all the way down to Knightsbridge, he combed my hair. I never said a word, I never turned and neither did he, and afterwards people said he was drunk which is absurd because he could understand the architecture of my hair, which is more than I can.

HEJIRA

I've been having the feeling recently, two or three times, that I might be on the verge of forgetting my father is dead.

I've been worrying one day I'll be on the phone to my mother and I will say to her: How's Dad?

I want to tell you our story but I don't know how.

Sometimes my patients don't know how to tell their
story and I say to them: Say whatever comes into your
head. I listen to what comes next very carefully and
I think about how that story is about the other story
they don't know how to tell. So why don't I tell you a
story, some stories? A stormy night, say (dark, for sure),
outside the rain is slashing it down like applause and a
woman runs out of the night in a beautiful skirt of some
kind, black, with her elbows raised up at shoulder level
as she runs, and she runs up to a woman with dark hair
she's never met before and the woman is frightened and
says, Jesus, and the woman who's just run in says: Where
am I? The woman says: I'm not meant to be here, I don't
understand how this has happened. The Jesus woman
asks, in a calm voice: What the hell's going on? And the
other woman says: There was an accident, a big fire. I
looked down, she says, my hands were all burned and
blistered. This is the opening of the music video for Kate
Bush's The Red Shoes.

There was so much smoke, says the woman (her hands are wrapped in bandages), I couldn't breathe and I couldn't, I was trying to find my way out! Oh please, you must help me, she says and: I can't use my hands, I can't use my hands, I have to get back.

Kate Bush does help her and the other woman (funny look in her eyes by this point, once Kate Bush has written down what she needed her to write down) says she wants to give her something in return. My shoes perhaps, she says. My pretty red shoes? Take them, they're yours, as a gift, for your kindness.

I find I'm wanting to play this video over and over this evening. The problem with the red shoes, as you may know if you know your fairy stories, is once you put them on they won't stop dancing. There is a film about this problem from the late 1940s. I ask my mother whether she knows about the film and she says: It frightened me. She says: Because the shoes take over, which is disturbing for a child. But it's stayed with me all my life so it must have been pretty disturbing to me when I was little, don't know why why. She says why twice like that and I write it down; she is cooking.

Hans Christian Andersen's story, The Red Shoes, starts in this way: Once upon a time, there was a little girl, pretty and dainty. But when it was summertime she had to go barefoot because she was poor, and in winter she had to wear big wooden clogs which made her instep grow quite red. The redness starts as pain you see, pre-dating the shoes.

When my mother was very small her father left her mother for another woman. Her father started a new family in a house with a tennis court and my mother lived in a house with a toilet that didn't flush because no one came to fix it. She says she followed the coal cart, picking up fallen coal. My grandmother worked in Boots the Chemist on Cross Street in Manchester and by her late teens my mother was working in promotions as a Living Fire girl or Mystery Shopper, selling products into shops in the North and the Midlands. She says my father was like a father figure to her, and, broken by his own family, where there had also been a divorce, he leant on her family for support.

In the middle of the village, Andersen wrote, there was an old shoemaker's wife, who sat down and made, to the best of her ability, a pair of little shoes out of some offcuts of red cloth. The shoes were clumsy but she meant well because she made them for the little girl, whose name was Karen. Karen took the shoes and wore them for the first time on the day of her mother's funeral. They were absolutely not suitable for mourning, writes Andersen, but they were the only ones she had, and so she put her bare feet into them and walked behind the simple coffin.

When my father's father left his mother, my father was sent to an expensive boarding school called St Peter's in York and he tended to have to stay there during holidays. My mother says he made friends with the headmaster's son, because the two of them had to stay when everybody else had homes to go to. She tells me my father never forgot that period of his life: the cold baths, the beatings, especially for not being able to remember things like poetry. He never could remember things, she says.

Karen is taken in by a woman, driving past the funeral in a big old carriage, who says to the vicar, OK, give that girl to me, and I will treat her kindly. Karen thinks the red shoes are responsible for this good fortune but the woman says they're nasty and she throws them on the fire. Some time later the Queen is visiting the area and she has a young daughter, the princess, and the princess has some really beautiful red shoes made of patent leather. Karen of course, is nuts for these shoes and when the time comes for her to go for her Confirmation at the church she swings it so the old lady (who doesn't see so well, apparently) ends up paying for, once again, these really not very suitable red shoes.

I read somewhere that Kate Bush's mother Hannah died the year before her album The Red Shoes came out and the album marked a difficult time in her life. There are so many losses in the Andersen story, such shifts of class and fortune, it's not surprising Karen maybe goes a bit . . . you know . . . if we're saying that to modern readers The Red Shoes is a story about madness and violence and grief.

I think we're supposed to judge Karen pretty harshly
for getting obsessed with these shoes and for being a
woman and then something else magical happens where
an old soldier with a red beard starts cracking on to her
and turns out to be a wizard or the devil or something
and he says what lovely dancing shoes and the shoes
start dancing and then Karen can't take them off and
she dances into a dark forest. Afterwards she dances into
a graveyard, Andersen writes: but the dead there don't
dance, they've got better things to do than dance. Long
story short, Karen dances to the executioner's house and
the executioner chops her feet off for her with the red
shoes still stuck to them dancing and the executioner
carves some wooden feet and gives her crutches, and after
two frightening encounters with the red shoes and her
dead feet blocking her way to church Karen becomes a
good Christian soul – Mercy! – and her heart fills up so
much with joy and light that she flies on the sunlight to
God and in heaven nobody mentions those fucking red
shoes ever again.

My mother says of course I don't know what she was like
before she married my father. This is something that's
come up a few times since he's been dead, that she used
to be very outgoing and gregarious then and had lots of
friends and now that's fifty years ago. She reminds me
that in the early 1980s she had a big family to support
her: my grandmother and her two aunts and her uncle
and their spouses, and whenever things were getting on
top of her she could talk to them about it, but by the late
1980s, almost all of them had died.

I was reading about manic depression and bipolar disorder this morning, something about the need to connect everything together; the whole issue of diagnosis is something I find hard as an analyst: whether people are a certain thing, if they should take medication, what we are doing by letting things be or just talking things through.

I get anxious because in a way creative activity always has a manic quality, dancing and dancing like the red shoes, like a nuclear meltdown.

I look at this book and the nature of its connections and I remember my father and how uncommunicative, how isolated he was; seeing the light on under the door in his room late at night thinking: What must he be doing? What happens in there?

In Martin Scorsese's documentary film Rolling Thunder
Revue there is the most amazing scene.

Joan Baez and Bob Dylan are standing by a bar and
chickachickchickchickchick she is making this noise with
her mouth and her tongue on the back of her teeth,
miming typing swiftly with her fingers and Bob says: I
don't. Jack Kerouac writes like tickertape. And she says:
I used to see you write like tickertape (looking into his
eyes); I used to feed you salad and red wine while you
wrote like tickertape. The camera angle changes and Bob
is smiling with his top teeth. He's about thirty-four here
but looks older. Yeah, I remember, he says. He starts to
speak and he gets out one word, which is: the. She says
over him: Brilliant stuff, William Zanzinger. He says:
Overlooking the Pacific, the wild Pacific Ocean in Big Sur,
right? It's like a scene from something, are they doing
this again for the camera?

William Zanzinger, she says (rich young white man, kills
an African American kitchen maid, six-month sentence,
plus ça change) and Bob says: Where was that written?
Hattie Carroll, she says, one of the best songs I think
you ever wrote. He says, I think it's one of the best songs
you sing. She says: How come you take it on stage now?
You won't sing it, he says and she laughs: Oh, Bob. Sure
I will. Just 'cos I screwed up the words. He says without
a break in thought: It really displeases me that you . . .
that you went off and got married and er, and then he
stops. She says: You went off and got married first and
didn't tell me. He falters: Yeah but I but er. He pauses.
You should've told me or something, she says. Yeah but
I married the woman I loved. She says, True. That's true.
And I married the man I thought I loved. And Bob says:
See, that's what thought has to do with it. Thought will
fuck you up.

I kind of hate Bob for saying that. For so many reasons.

I am thinking of my mother typing, sitting at the 1980s pine kitchen table in the old house: my mother and father are working from home by this time, he is an accountant and she has given up her job to help him (as they get older she increasingly runs the business, he'd have a week or two off now and again but I don't think his clients were any the wiser).

Changing the ribbon of the typewriter was very complicated, I remember. Sometimes the typewriter would get angry and make beep-beep noises for no reason, and my mother would be cross. I remember the typewriter when it deleted things, the clackaclack noise of the erasing ribbon.

In 2001, when I came out to my mother on the telephone, after an argument about a girl she didn't think was good for me, my mother said: Are you? Really? I've always thought your father might be gay. Or at least bisexual.

One or more men are at an airport talking on the
telephone, in real life. It is a Saturday morning in August.
A man says: Everything Fabergé does is vulgar. He says:
How can you like an egg and not like that? A man says:
Everything dark has been burnt. He says: Everything
dark is subject to heat. And: All the high points were
scorched to nothing. And: Arizona. And: I think there
was another sun, the sun we've got now is a new sun,
this sun is on the way out as well. And: I think the ice
age happened because there was no sun, no nothing. He
says: Sub-zero temperature overnight. A man says: Three
course of bricks, ordinary bricks laid flat, then you've got
the faces of the bricks, you're covering over the damp and
you're doing like a slant, you've got, you've got a course
of bricks, can you hear me, hello?

He says: You've got a cover.

He says: What I'm saying is.

He says: You can't see.

He says: You can't come out.

He says: Width of another brick.

A very long time ago, God the Father saw that the people living on the plain of Shinar were building a tower, which would stretch up all the way to heaven.

God went down to have a look at what they were doing and it worried him and so he made the builders speak different languages and it ruined the building work. This is the story of the Tower of Babel, a story about how languages came about.

Everyone is connected, and no one speaks the same language. Everything is connected and everybody is alone.

Joni Mitchell is being interviewed by Morrissey and she says: Well, I don't think I'm prejudiced against words per se except the ones that come up through psychology, you know, because they've ruined the English language.

Joni says: Neurotic, Ego. I don't like those words. All of the psychological words.

She says: You know, I see them bandied around and think that damn word has killed a lot of words that . . . because they've taken the heart out of life in a certain way.

Joni says: Like neurotic. Doctors love to levy that at just about every woman that crosses their threshold, right?

Joni says: Did you ever stop to think, she's anxious? You know, like there are other things that have more compassion and more understanding to them.

My friend tells me another story about Babel, from the
Pirkei Avot (the Chapters of the Fathers). It is said that
when a brick fell from the tower, she translates for me,
the builders cried, but when a person fell, they shrugged.

Boris Johnson is prime minister now. Today they dropped the investigation into Mark Field, MP, grabbing Greenpeace protestor Janet Barker by the neck. I have the image of the film of it in my head as I type; no faces, just the grabbing at her neck.

I am thinking of Bob Dylan's lyrics about William Zantzinger, from The Lonesome Death of Hattie Carroll, about philosophy and criticism and disgrace – tears wiped away with a rag.

I remember a number of years ago I was in a toilet
cubicle with a man and he grabbed my throat so
forcefully I heard things I don't have names for around
my Adam's apple clicking like tickertape. I thought, Oh
dear, something has happened. Has he broken my neck?

I have a fight with James because I said I'm going to stay up and finish my book and James said: Is it a two-chapter book? I am hurt and angry.

I have not explained and so he does not understand why. I have been worried I have to do it all on my own and that nothing is joining together.

What I am thinking is: How can you love me when you don't understand me?

I am not thinking: I fall in love with things I do not understand all the time, that's the exciting part. I am not thinking: I love you – which I do. I am not thinking: I am in pieces and we do not understand each other and my father is dead.

For the last week I have dreaded to look at the pieces or see how many there are because I know they don't join up. And today I looked at them and there was most of a section. Except in pieces.

It is in pieces because I am still, on this issue, in pieces, after all this time. It seems like ages.

I am trying to do three or four things as best I can, including this relationship, and conceivably, although much of the rest of things would fall apart, in particular having somewhere to live, I would be better at writing if I was alone.

God made the builders all speak different languages.

Even before Babel, alchemists were searching for the hidden method by which base metal could be transmuted into gold. Others thought this method held the secret of converting the body into pure solar energy (of which gold is said to be the earthly vessel) and thus becoming immortal. These days you actually can transmute matter if you're in possession of a particle accelerator, though you don't get much gold for your money.

Al-kīmiyā: the process of transmutation by which to fuse or reunite with the divine or original form.

Exciting changes!

Your patient is worried she cannot write unless she smokes crack. Tonight you spoke of how she feels like she is making a bargain with the devil, which of course she is and so are you.

Feelings are a devil too, rushy, like the crack she smokes.

Your patient tells you about an article she has read: she must stop reading, she says; she starts reading and she has to finish everything and it takes hours and there is no time for writing.

She tells me about an article she has read in which an autist, she corrects herself, an arsonist (the arsonist is a young man with autism), starts a fire to let out his feelings. Ten people die in this fire.

The young man watches the fire spread across the neighbourhood and then he goes to help the neighbours with the fire.

Later, you light a candle in a glass tumbler which sits on the bottom-left corner of the bath in the corner with the wall. The light of the candle is reflecting off the white tiles of the corner of the wall and steam is rising from the bath.

You see it rising around your foot (the steam) and part of it (your foot) is in the water and part of it is out of the water and part of it is hidden by the reflection of the candle in the bath.

It's quiet and it is too dark to read.

In the bath, you are thinking:

autist

arsonist

artist.

In the bath you remember a story you loved as a child, by Arnold Lobel. There once was a mouse who was dirty, so he takes a bath. The water filled up the bathtub. But the mouse was still dirty, so he let the water run over on to the floor. But the mouse was still dirty, so he let the water run out of the window. But the mouse was still dirty, so he let the water run all over the whole town. The people in the town cried: turn off the water! You are very clean now!

Arnold Lobel wrote this in the late 1970s, incidentally, a few years after he told his wife and children he was gay.

Arnold Lobel died on 4 December 1987 of a cardiac arrest (588 days after the nuclear accident at Chernobyl) after suffering from AIDS for some time.

During the session you said to your patient: You want to start a fire.

In the bath, you are thinking:

But it's you who wants to start a fire.

It is you who, when your patient has finished her story, wish most of all to say, but do not say, because it is not safe: Shall we start a fire, and burn down the room? Shall we let the fire run over the whole town?

Shall we make a fire, and watch, from the roof of the
building, and then go down and help the neighbours put
it out?

My patient has brought me a story about myself.

I realise this as I write, in the bath in the dark on my phone with the light of the candle and the tiles.

I write: Your patient has come to find someone that knows how to start a fire, and then come down and help the neighbours put it out.

How strange it must be to come into the room with this
therapist, who does not communicate like normal people.
Who does not always hold eye contact. Who, when the
patient asks, How are you?, mumbles politely, Oh, fine,
and waits to find out who is really who today, in a bargain
with the devil in this strange room somewhere between
art and medicine or magic (something alchemical or
shamanic), where the therapist takes on different parts.

And you think of the photographer Joel-Peter Witkin,
surviving identical twin of triplets (one miscarried) who
takes religious pictures, renaissance in style, of body
parts or circus freaks; who inspired the fashion designer
Lee Alexander McQueen to create the final image of his
fashion show Voss, a mirrored box within a mirrored
box containing scenes from a lunatic asylum, which was
Michelle Olley naked and masked, covered in live moths,
breathing through a plastic tube.

Lee Alexander McQueen hanged himself on 11 February 2010, the night before his mother Joyce's funeral. He was forty years old.

[

]

I wrote down the reasons why this happened, which I've read in books or heard in documentaries. I hate them so I took them out.

Joel-Peter Witkin: I find it difficult to separate the three (two) parts of his name.

Lee Alexander McQueen is also a name in three parts – it was Isabella Blow's idea for him to use Alexander for business; the person was Lee – writing them down all at once feels like too much.

Joel-Peter Witkin enlisted in the United States Army as a war photographer to take images of Vietnam, but was never deployed.

In 1982, at the medical science department at the University of New Mexico, wrapping up in nylon gauze the two laterally bisected parts of a head, Joel-Peter Witkin for a moment sees the two halves kiss and takes a photograph and is banned from the medical science department and is told he must give up the negative.

He calls the photograph The Kiss.

Tonight on Twitter, before the finale of Love Island, a
friend shares a poem called Holdfast by Robin Beth
Schaer, which begins:

The dead are for morticians & butchers
to touch. Only a gloved hand. Even my son
will leave a grounded wren or bat alone
like a hot stove.

It ends in the most extraordinary way, this poem,
describing an experiment on baby monkeys who are
given the option of choosing between a mother-substitute
made of wire but from whom it was possible to drink
milk and a terrycloth mother who was more comforting
to hold but didn't offer nourishment. Like them, writes
the poet, I would choose to starve & hold the soft body.

Witkin says: It happened on a Sunday when my mother was escorting my twin brother and me down the steps of the tenement where we lived. We were going to church. While walking down the hallway to the entrance of the building, we heard an incredible crash mixed with screaming and cries for help. The accident involved three cars, all with families in them. Somehow, in the confusion, I was no longer holding my mother's hand.

At the place where I stood at the curb, I could see something rolling from one of the overturned cars. It stopped at the curb where I stood. It was the head of a little girl. I bent down to touch the face, to speak to it, but before I could touch it someone carried me away.

Erin O'Connor, tangled in balloon strings on the merry-
go-round for McQueen's runway show for Autumn/
Winter 2001, has to stay in place while a succession of
models subtly attempts to set her free. She is one of the
core group of women who work for McQueen season by
season. In Voss, the previous show, he asks her to rip off
her dress, which is made of razor clams.

Realising after the show her hands are bleeding,
McQueen apologises; realising an ironic thing, that she is
bleeding and that the models are dressed in bandages, he
takes Erin O'Connor's hands in his hands and he places
them on her head softly, among the bandages, around her
ears.

Erin O'Connor says: I had worried that it looked like in some way that I was victimised or a victim of being, you know, sort of in that mindset and in that mindset and actually it was the complete opposite, it was stripping away sort of the . . . the pain and the armour and just going, Here I am, you know.

I've kind of surrendered, she says, I'm right there at the end and I've gone: this, this just happened, this just really happened and he pushed me and I'm glad.

It is the Spring/Summer 1999 show, called Number 13, and McQueen is standing behind the raked seats of the audience in a blue shirt. The show ends with two robot arms, almost person-sized, dancing together, and spray-painting Shalom Harlow as she rotates on a turntable in a white dress. She moves her own arms too. Robotically. Sometimes as if she's trying to shield herself, sometimes as if exploring what it's like to be a robot too.

In Ian Bonhôte and Peter Ettedgui's film about McQueen, you can see a blow-up of the designer watching the finale of Number 13. You see him place his hands on top of his head, fingers interlocked, elbows wide, and the effect is of what he is watching gently, firmly pushing him backwards and upwards. After the lift, the push, comes the reaction, and you see his brows furrow slightly and the pink-lit hand of the rotating model falls between the camera and his face, hiding it from view; falls past his face and you see McQueen's head rock, rising up and down, scalp still in the grip of his hands, elbows splayed, heaving and you see his teeth exposed as he breathes out what could be a laugh or a gasp or a sob. Interviewed later, McQueen says it is the first time he cried at his show.

You step outside to go teaching and it is pouring, early summer rain. Starting to drive and you are thinking of the rain and the model, the rain hitting your windscreen and the wet black of the paint and the yellow of the wet paint hitting the sloping cantilever of the white tulle dress as she spins and you have to pull over in the rain and write it down.

This living hand, now warm and capable
Of earnest grasping, would, if it were cold
And in the icy silence of the tomb,
So haunt thy days and chill thy dreaming nights
That thou wouldst wish thine own heart dry of blood
So in my veins red life might stream again,
And thou be conscience-calmed – see here it is –
I hold it towards you.

Keats wrote this in about 1819, two years before his
death from tuberculosis at twenty-five. The lines go ten
by ten by ten by ten by ten by ten by ten by six. Like
something was cut off.

Jacques-Alain Miller says: Making sense is already delusional. And that is a very deeply held conviction of Lacan's.

Jacques Lacan was a French psychoanalyst; he had been dead for twenty-seven years when Miller gave this address in Paris in July 2008. Lacan was the foremost psychoanalyst in France up until his death in September 1981, describing his work as a return to Freud. He was Miller's father-in-law.

Miller says: In practice, when you understand what the patient says, you're captured by his delusion, by his way of making sense. Your work as a clinician is not to understand what he says. It's not to participate in his delusion. Your work as a clinician is to understand the particular way, the peculiar way he makes sense of things.

The paint is black and green, incidentally, on the dress. It only looks yellow in the video.

You walk down a narrow street between houses and there is a sign in a window which reads: I DEMAND A PEOPLE'S VOTE ON THE BREXIT DEAL.

Next door but one the front door of the basement flat has two rounded impressions, gouged out of the white paint and the wood, as if someone has tried to smash it in.

It is raining outside the train and small drops of water are coming through the roof. It may be the air conditioning but it feels like the outside dripping into the inside, around the light fitting. That's quite dangerous, says someone else on the train.

When one cannot bear the uncertainty one speaks, which is an act of violence.

Leaving the runway is all roaring and petrol; leaving the runway and returning to the runway is the part of the flight most likely to kill you, where the fragile skin of the plane is most likely to be made to smash outwards, puncture the fuselage, infolding metal destroying passengers and crew.

When I kill the silence, I want to kill the space between us, full of nothing; like a raincloud which the plane is passing through.

Joni sings about clouds, of course, in Both Sides Now: looking up at clouds from the ground and looking down at clouds from a plane, and knowing the reality of clouds is somewhere else entirely.

John Berger: Clouds gather visibility, and then disperse into invisibility. All appearances are of the nature of clouds.

On my friend's Instagram page there are two huge roses. The size of my head, she says. Then what you see moving down the page is three rowing skiffs in a vast orange river, is a page clipped from Jeanette Winterson's Frankissstein: Nationalism is on the rise, I say [. . .] A fear. A refusal of the future. But the future cannot be refused.

You are going to be late for your teaching.

A rose, a rower, a rise, refuse. The river flows on, all junk, blown back by the explosion of water and you are thinking of the damaged concrete of the fish farm next to Fukushima, concrete smashed outwards by the 2011 tsunami's yellow-and-orange flotsam, plastic refuse. You are the water, you are the boat, you are colour and flow. You are the son and heir. We are air, we are not earth.

At the runway show reprising Dante (Fall/Winter 1996) in New York, McQueen is shouting at everyone. The seating chart is missing, the press team have no headsets; the press team has to run to relay the chaos out front. All is roaring and noise.

Anna Wintour is lifted over a cab and through the ropes: yellow cab, orange Philip Treacy hat on Isabella Blow up there in the gods, who delayed the show in London while she had a drink with Bryan Ferry (Driving Me Wild).

As the plane lands there is the curt scream of black tyres on tarmac (A Hard Rain's A-Gonna Fall). McQueen changes into a three-piece suit and puts black contacts into his eyes. There is organ music and gunfire. Writing this on the cheap evening train to Stoke you remember ten minutes ago the automatic door of the toilet opened and the flooded floor behind it, and a rivulet of piss flowed out on to the carpet of the carriage: yellow and olive and dark blue, damp and wet, on dry of baked-in dirt. (Slave to Love. Don't Stop the Dance.)

Joni says: Usually the music comes first, OK. I play the music over and over. Mostly, I write at night. Here's where the pinnacle thought has to go, here's where the high note, the main thrust the most important idea has to go because this is the pinnacle in the music.

Joni says: What is this music craving as a story?

James had been to Japan before; I remember him showing me photos when we were first together, of him sleeping in a pod hotel and petting Japanese cats. With the patience of a saint he'd taught me to ride a bicycle a couple of years earlier (there was a tricycle I was very fond of as a small child but my father kept getting bicycles that were too big for me so I could grow into them and I never really learned) and this was to be our first proper cycling holiday, a trip around the Seto Inland Sea. When I asked about visiting Fukushima for the book James pointed out this was like breaking a Cornwall holiday with a trip to Aberdeen, but he was curious about Fukushima and we booked a tour day organised by Karin Taira who runs a B & B in the area. She arranged for us to visit another local resident on farmland within the evacuation zone. Only a small proportion of the original inhabitants, mainly elders, chose to return once permitted.

The area outside the farm is roses and roses in plastic tubs. We are a few kilometres away from Fukushima Daiichi, the TEPCO power plant whose reactors exploded following the earthquake and ensuing tsunami in March 2011: the most severe nuclear accident since Chernobyl.

Seimei Sasaki is ninety-four and sits with a duvet round him at a sunken table that has a heater somewhere underneath it glowing orange that I am worried about touching with my feet.

He's interested to hear I am a psychotherapist: as he gets older he feels his mind is not as sharp as it was; do I have any suggestions? I point at the television, shaking my head and we mutually decide this response must have lost something in translation and not to mention it again.

I want to know about wild boar and I ask him. Their numbers are increasing, he answers. They are very destructive; big like tanks. He's never tasted boar.

They've been farming here for five hundred years apparently; Seimei's son has a big business importing English roses to Japan and the family was paid 5 million dollars in compensation from the government and from TEPCO for their damaged stock.

Thinking of the resettlers after Chernobyl I ask Seimei-san if he dreamed about his house when he went away. Yes, many times.

I want to ask endless questions about these dreams, so I can imagine Seimei-san standing at the edge of his forest, or at the turn of his driveway as the topiary next to his house comes into view, or on the threshold inside, at the step where he must remove his shoes.

Later in another abandoned town we see a boar. It is larger than I imagined, hairy, bold as brass on a deserted lot.

General Electric told the farmers in the sixties when they
built the plant it would be safe, Seimei Sasaki says. An
American company, they didn't know about tsunamis. We
did not know about nuclear. When the accident happened
we had to leave immediately in the clothes we were
wearing.

Joni sings about seeing a building like this on her journey
in Coyote, way out in the dark between places, on fire.
They watch it being taken by the flames. There is a we
in that part of the song, though it's not clear who we is,
maybe Coyote, maybe not.

I had a dream that I was in a funeral procession in Brixton in the street, not far from where I go to therapy. It might have been for Martyn Hett, a young PR manager I used to follow on Twitter. He died when Salman Abedi bombed the Ariana Grande concert at Manchester Arena on 22 May 2017. In the dream, I was holding a little book of photographs, and though I didn't find the procession sad, I could feel the sadness by flicking through the book of photos like a flick book, watching the pictures moving like a scene.

I couldn't tell you why Martyn Hett made such an
impression on me that he is in my dream, but I think it
has something to do with The Audrey Roberts Noise.
My parents watched Coronation Street religiously when
I was growing up through the 1980s and 1990s, during
which time Audrey worked as a hairdresser and was the
wife of the mayor. Martyn noticed that Sue Nicholls
who plays Audrey has a noise that she makes when
she finishes sentences: Hn? or Hmm? or Uh? and he
edited twenty-two clips together into a video just under
a minute long. We see Audrey going through all these
conflicts and heartbreaks and every time there is this
little noise: Hmm? A lot of people watched.

During an argument, I say: I try to make you understand.

No, James says, you don't.

It is so hard to explain. It's like I'm seeing you in a photograph album. It's like you're in a story or on television. There is a barrier and I can touch you, but your feelings for me are far away. As if they were for someone else.

Another visual reference McQueen used – and there could be hundreds of references in every show, he was really phenomenal like that, but I'm thinking about his Horn of Plenty collection for Autumn/Winter 2009, which was about garbage, last season's fashion becoming landfill, McQueen parodying iconic fashion pieces and things from old collections (the models seem huge with huge Leigh Bowery lips like drag queens); a pile of crap sprayed black the year before the Deepwater Horizon oil spill – maybe none of this is important. I'm thinking about this Dutch photographer, Hendrik Kerstens, who started taking photographs in his forties of his grown-up daughter Paula, styled like Old Masters portraits but what she has on her head turns out to be loo rolls or plastic bags. He took photo after photo of Paula like this, and she has the most penetrating expression as she looks back at the camera.

What is happening in this moment?

I find myself thinking: Paula has to look through her
father, in order to see out into the world.

At Iwaki-Ōta, there is a schoolgirl on her bicycle at
the railway crossing. At Iwanuma, there was a woman
on the verge by the train with her bicycle, gathering
handfuls of something green. There are black-green tops
of mountains coming out of cloud and there is a cherry-
picker fixing a telephone pole, and here and there is
cherry blossom, which is over in the south. It is 28 April
2019 (two days and thirty-three years after the nuclear
accident at Chernobyl).

In the morning we clean ourselves in the hotel onsen.
There is an upturned plastic bucket for you to sit on,
washing yourself with a showerhead before you sit in hot
water.

There's a page in this section about Joni's illness which is the only part my mother has read. When she'd finished reading I felt very emotional, thinking: Joni is the closest I've come to saying something I want to say about you in all of this, something about what you gave up of your own desire, for me and for my father.

When you go to Fukushima and that whole area of
coastline you have to get your head around the fact that
there were three very significant disasters here which
happened at the same time. The earthquake. The tsunami.
The reactors that exploded. It is too much to take in.

The saddest thing about the Exclusion Zone was passing
acre upon acre of black plastic enclosing contaminated
earth. They removed the first three centimetres of topsoil
across the entire contaminated area. I am in the bath
trying to remember something Andy Warhol said about
plastic: I love Hollywood [. . .] beautiful. Everybody's
plastic – but I love plastic. I want to be plastic. Exploding
Plastic Inevitable (Chernobyl; Fukushima). Every person
on earth will be held responsible for the suffocation
of the world via plastic and for the triple disaster of
Fukushima and for the Chernobyl explosions but only for
fifteen minutes.

For Number 13, all is black and blue. There is a crack of blue neon running round the ceiling, like the first crack of a blue dawn.

If you were invited, this is McQueen's vision of Spring/Summer 1999 (it is 27 September 1998, it is autumn outside). You have been holding an invitation which is two-thirds a photograph: black and blue and white. It could be a night sky or water. There is a black area with white points like a star field and in the top right is white or the light is coming, and in the white third which contains the text there is: Alexander McQueen #13 and at the bottom (all in capitals, but quietly):

DEDICATED TO MY DOG MINTER.

You are sitting in a four-by-four and what is outside
the windows as you drive for minutes and minutes is
16 million bags of irradiated soil, covered with black
plastic, surrounded by white fences. You look at it and it's
still there and it's still there. It's still there. It doesn't go
away.

She is swinging her long arms now; she is the first model in the space, swinging them in time, hinging at the elbow so that her hands, held halfway into fists, kick up now and then to meet the cleft of her breasts. Here is a woman in the mostly-dark dressed in black or blue and long, thick platform heels and what you can see as they're rising out of a black-and-blue dawn is two blunt points at the base of the outline of whatever it is she wears that terminates a little off the floor (a dress? a coat? a skirt?); points, which are moving like her arms.

Left, right, left, right.

She stops in the blue light and holds the edges of her jacket like the lapels of a suit and the lights come up into white.

The swing is repeating now as the second model comes out to occupy the broad space of the Gatliff Road Warehouse, broad and boarded like a stage; her skirt follows the line of her waist and thigh down to a few inches from the knee while at the same level the broad unexpected tails of her jacket swing slowly in the opposite direction to the movement of her legs. Two dresses, not backless but with a long sliced-out section between the shoulder-blades (where does this start and end?) like a surgical gown.

Now the long black swinging section is at the front of a skirt, now you see it in the long flared crease of grey trousers. It is a heavy, easy swing: left and right.

Now the focus has expanded and you are struggling to keep up, multiple women on the runway, grey, blue and silver, four minutes in and twenty to go, hard bodice with mirrored segments, unexpected lengths and areas of bare skin, breasts beneath shirts.

Here you are experiencing fabric placed in ways you
have no names for, maybe it is the top part of a jumpsuit,
folded down below knee level, arms swinging by legs,
long fingers of dark hair snaking down forehead, across
the eye or the nose.

Blue-grey has become turquoise and now white and
now ruffles are beginning to repeat themselves from one
woman's collar to down below another's back or hem.

Eight minutes and it's wide confident lines and squares,
ruffles all down, strange long bib chemise – something
about this collection that brings this word chemise to
you, the day you're in Paris napping on the ground in the
Place des Vosges, chemise that makes you think: *chemin
de fer* – video again now, vast surprising soaring wings
in rigid pale balsa (Erin O'Connor! where have these
come from?) reaching high above and behind the model's
head; now it is creams and light woods and whites then
returning to black.

Halfway through the video the energy to describe
these things fails you for a while and you are watching
yourself straining to find words for arrangements of
clothing from twenty years ago that you are watching on
YouTube, probably to the wrong soundtrack.

84 per cent of all unwanted clothes end up in landfill.

conversion plant

As you sit on the train your eye is drawn to the enormous chimney of a waste-to-energy conversion plant outside Wolverhampton.

There is the chaos of a scrapyard, a tyre shop. Crown Street. Fox's Lane.

A friend does an Instagram post quoting Jack Spicer's Letter to Lorca: I would like to point to the real, disclose it, to make a poem that has no sound in it but the pointing of a finger.

But things decay, Jack writes. Real things become garbage [. . .] but the garbage of the real still reaches out into the current world making its objects, in turn, visible.

As things decay they bring their equivalents into being.

The French phrase for railway – *chemin de fer* – is literally ironway; I'd never noticed that before. Outside the Comédie-Française there is a great line of people, red-and-white plastic cordons, wind, a grey sky. *Paris autrement.*

I do the Eurostar return alone. I can't remember why.

We are travelling at 192 kilometres per hour.

We are travelling at 284 kilometres per hour.

We are approaching the border with the UK and it is all chalk and white fences and dark barbed wire.

When the train arrives at Ebbsfleet we have to wait before they open the doors, they say: There has been an intrusion. Is someone on the train? Is someone outside?

At Sendai Station the morning we go to Fukushima,
James is floating about not finding what he wants for
lunch. I'm worried our train will be cancelled, that there
will be a disaster. I have derailed the holiday, wanting to
come up here. There are angry red letters on the train
below ours: Rapid Rabbit. There are Wurlitzer organ-type
sounds as the doors close, then there are string-quartet,
train-leaving chimes.

In New York City, subway cars have a device that
converts direct current into alternating current which as
part of its normal operation emits the first three notes
of the song Somewhere from West Side Story, about
belonging. In London, the doors are just tolling bells:
there is no place for anyone here and we are all on the
clock and displaced and underground and we are nowhere,
paying for it through the nose.

Leaving Sendai on the train we pass Aeon supermarket, point at a boxy car in the street, at the famous Hokusai wave painting, which is advertising something. That wave is painted using a combination of traditional indigo and Prussian blue, the same compound which is given by mouth or by nasogastric tube to stop radioactive caesium isotopes being absorbed by the intestines. Yesterday at Ishinomaki there were signs, high up on telegraph poles and on the walls of buildings in the middle of the town, showing how high the water came. Phrases came and went in my head: wall of water; endless advance of sea. It's too much to take in.

One of my favourite Arnold Lobel stories was about a night when Owl felt sorry for winter, opened his front door and invited winter to come in and sit by the fire.

Winter came into the house.

It came in very fast. It turned the pea soup into hard, green ice.

Something else is happening now, halfway through
the video of the Number 13 show: models with large,
high, solid balsa skirts rotating on turntables spot-lit in
darkness, hands tucked into front pockets so their elbows
fall behind them like wings.

Lights up, start again. Something else is coming in,
something from outside of Europe; here are fringes of
skirts, which are swinging like grass and here are thick
woven dresses. Here are leather straps and buckles,
snaking across where I am expecting the back of a
jacket. One thing turns into another: leather buckled
hard leather corset into neckpiece, into high-up shorts
like armour, moulded in towards the model's skin, thick
lacing coming through leather eyelets like stitches in
skin, Aimee Mullins, moulded armour leather body-piece,
strap, rough stitches, carved elm dark prosthetic legs
carved with winding flowers, vines, grapes, thin carved
ankles which become the shape of high, broad-pointed
high-heeled shoes.

Writing all your writing about Number 13 in a big wodge and being angry about it; trying to write about fashion in an intelligent way and being repeatedly stuck with words like model and girl and woman and trousers and not having anything adequate for putting life back in – there is a shape in the dark, it is moving and the shape is doing something to you and you cannot say what the shape is doing.

Something is missing from the video here or lights fade down and then it is five models on turntables, one head and shoulders covered to the waist in glittering silver fabric, another circled by wide spirals of barbed wire.

Now towards the final image with Shalom Harlow and the robot arms and the white tulle trapeze dress, spray-painted yellow (green) and black and it is over now. Harlow's walking out and there is the brilliant neon blue and darkness and the UV light on her white dress and the glowing yellow (green) of the spray paint glowing in the darkness and the UV light and somewhere in the darkness McQueen and his tears.

Sometime in late spring you are walking through London, north of the river, and you are surprised to be walking past the Home Office and its silent street. Across the glass entrance to the Home Office you see someone has written the word GUILTY in pink spray paint. You are not expecting this to have been allowed and you are thinking: How are they going to get that off?

People are standing around in silence. This seems like a big deal but there is nothing about it on Twitter.

You are aware of indistinct police lights; the car is round a corner, but you do not see police.

There are security guards, who are Black, and office workers, who are mainly white. There is a young cyclist wearing incongruously bright palm-tree socks.

There is the foggy Japanese sea in spring, and the fish farm by Fukushima. Seven people died at the fish farm when the wave came. After the nuclear accident their bodies stayed there for two weeks.

Beautiful light aroma of salt.

Cars in the car park at the old people's home look normal until you notice flat tyres. Someone has written the word TERROR in pink spray paint on a car. You are told it was climate activists.

Joel-Peter Witkin says: A person is rubbish to the state, that's a person who's loved.

He says: The body isn't yours. It's taken away from you. He says: You are born and die in an institution which claims your body, that there are two times in life when you are totally innocent, before birth and at death. He says: We should discard our prejudices so that, like Dante following Virgil, we can step into another realm.

You walk past the Eagle one night and there is a man lying on the pavement having been asked to leave. The man is lying face down without his shoes on, saying repeatedly: Dial 999 now, dial 999.

Later when you are walking home there is a man a little older than you sitting on the pavement who seems to be very high on GHB. You and another man in the street think he is going to overdose and you walk him home, which turns out to be the building where you used to live.

A few minutes before the three of you arrive at the building the man goes to look intently under the seat of a bus stop as if there is something hidden there he has just remembered to look for. He thanks you with a strange false-cheeriness as he leaves. You think: He has decided you are going to rob him.

A small girl in a yellow dress is playing on the Underground platform. The girl says: Someone's crying, it's an emergency.

Joni

Where's Joni? In hospital trying not to die, trying to hold her insides in. Joni had polio as a child, Joni had a brain aneurysm in 2015 and fibres, red, black, have grown out of Joni's skin like mushrooms after a rain storm or she's felt things crawling under the surface. For several years Joni could not leave her house, she could not wear clothes. Flying exposed her to heavy metals, exhaust fumes from the plane kicked back into the cabin: she'd be sick for a week after she flew.

In Lakota, Joni sings about water making a noise like an animal, frightened of dying, or machines.

Joni writes this fear into the trees, the soil. Joni sings about how the whole world is a woman in pain and that any place you place your hand it hurts.

When you were young, you remember your mother having premonitions sometimes, not long after her own mother died. She once told you she had seen the blue flashing light of a police car – an ambulance, perhaps it was – in her bedroom late at night.

Awkward from the very beginning, I turned round undetected in the womb shortly before I was due to be born; stuck in the birth canal, I ended up having to be cut and pulled out of my mother. It seems there was some consequence of that operation, and when I was six or seven my mother started to feel ill. Doctors told her various things suggesting nothing much was wrong until one day we were on holiday in Wales and an old doctor was standing in for the usual GP. He said, I think you're a very poorly lady; you need to go to hospital as soon as you get home. It turned out she'd had septicaemia for goodness knows how long and they had to go in and clear everything out. I think she nearly died.

Joel-Peter Witkin is describing how he was working in a bar getting through college, working for the owner who is called Jimmy. Witkin is describing a man, a Black man, coming into the bar drunk, asking for money. He says: the Black man was making a nuisance of himself. Jimmy takes a baseball bat and he hits the Black man. Witkin sees: the bat crush the Black man's face. The Black man: is killed. Witkin says: the police dragged the body of the Black man out of the bar and they continued with the business of the night.

I wish I could tell you this person's name, this living man who is now earth, as this bat will become earth, as those who raise weapons in violence will become earth. I hope one day it will stop but I don't know it will stop until everything stops. Pressed down by sedimentary rock, dead matter on the ocean floor forms a dark layer, becoming oil.

All this whiteness – writes Frantz Fanon (psychoanalyst of colour) – burns me to ashes.

Still many people are suffering inconvenience as evacuees.

People became anxious about invisible radiation.

Power supply for TEPCO declined.

We apologise.

TEPCO became deeply aware of the reality that our confidence about safety was merely arrogance and overconfidence.

Faithfully facing this fact, TEPCO sincerely regrets the events.

The fission of the British Empire was just one of the nuclear experiments conducted in the years following the Second World War. Its technicians briefly evacuated and are now returning to the same buildings under plainclothes and corporate flags as children continue to die. The break-up of empire is a nuclear disaster that must and that cannot be grieved.

An expert in art explains that: Witkin's hospital sweepings are not justified by any larger movement in history at all. I think I can get the message without, she smiles, luxuriating in the gory details.

Rachel Carson writes:

The dramatic and the catastrophic in earth history have left their trace in the sediments – the outpourings of volcanoes, the advance and retreat of the ice, the searing aridity of desert lands, the sweeping destruction of floods.

Rachel Carson writes:

The sediments are a sort of epic poem of the earth.

Google says: People also ask: Is Rachel Carson married? What Rachel Carson is famous for? What did Rachel Carson die of? What are some fun facts about Rachel Carson?

Rachel Carson is unmarried.

Rachel Carson is famous for writing Silent Spring about the effects of pesticides on the environment and also The Sea Around Us, which was adapted into a script she hated that won an Academy Award in 1958.

Rachel Carson died of a cardiac arrest on 14 April 1964 (twenty-two years and twelve days before the nuclear accident at Chernobyl). She had cancer.

Some fun facts about Rachel Carson are that Rachel Carson's ashes are in more than one place: next to her mother in Rockville, Maryland, and at the margins of the sea, at Southport Island, Maine.

Some fun facts about Rachel Carson are that in the summer of 1953, at Southport Island Maine, she met and fell deeply in love with Dorothy Freeman, who was married. In her letters to Dorothy, which are collected in a book called Always, Rachel, she says her love is boundless as the sea.

A sign on the train reads: it is safer to stay on the train than attempting to get off.

A sign on the train reads: Please help people off the train if they feel ill.

You are watching the version of Ivor the Engine from
the 1970s, which is filmed in colour. Idris the dragon's
volcano went extinct: I was ever so cold, my whole family.
In this made-up, English confection of the top left-hand
corner of Wales where you want to scatter your father's
ashes on the margins of the sea, the volcano is reignited
using gas-pipes when you feed half-crowns into a meter
and Idris is singing the descant to Land of My Fathers
with the Grumbly and District Choral Society.

The light is on in your father's bedroom. It is the first time the light has been on at night since he was alive.

You look at the square of light around the closed door, in the dark hallway.

That night you dream of Chernobyl again, getting off the train at the border of the Zone.

It has been snowing.

Britannia is under the clouds today; it is raining. The rain comes down indiscriminately, caring not who it soaks. There is an endless grey, which when you stare at it is purple, is yellow, is pink and has been slate grey, ash grey, all along.

One afternoon at home in your little room alone you are watching the Martin Scorsese documentary on Netflix about the Rolling Thunder Revue. Allen Ginsberg was there and Joan Baez and the band was called Guam. Rolling Thunder was the name of the US three-year bombing campaign in Vietnam, and the name of a Native American medicine man, Chief Rolling Thunder: a hippie leader who was born John Pope and never proved he had Native American heritage at all.

Rolling Thunder says: Columbus didn't discover America, there were people here already. Even though they stole most everything they could get their hands on. Our land, children, women, whatever, they took it. Left us very poor people, lot of our people homeless in our own country. But the best things of all, that they had no value, was our way of life. It's beautiful music when that thunder rolls. And that's the way I got my name. I used to scream like a little eagle is what they told me, even when I was a baby in diapers. Run right out in the storm.

Joni is singing her song Lakota, about the Black Hills land claim, and what governments do with land in remote areas with their power stations, their military bases.

Joni's song was released in 1988, over a hundred years into a dispute between the United States government and the Sioux Nation about the ownership of America's oldest mountain range, thickly forested with the pine and spruce trees that give the Black Hills area its name.

Joni knows she is not Lakota. But after the song comes out, Joni is invited by the Lakota-Sioux to march as a dignitary with their chiefs and their medicine men.

Joni says: Men, all men, the women were upset about it, a white woman marching, a blonde yet. Custer was a blonde, all their enemies were blondes.

I'm drawn to a question Joni asks in this song, about the process of restoring something lost or stolen to its proper owner. Is that what I'm looking for, compensation? What is it I think that I owned?

You are watching Rolling Thunder Revue again. Bob is
in white make-up with flowers in his hat and there is
Richard Nixon, who says: We act not just for ourselves
but for all mankind. There is America chased out of
Vietnam, and here's Scarlet Rivera and there is Joan
Baez dressed as Bob Dylan in his white make-up and his
flowered hat and all the crew are fawning round her like
they can't tell the difference, and Patti Smith is there as
well.

Patti says: And the archer looked at his sister and said, all
the madness between me and you is real private.

It's May on the train. Seed-heads float about inside the carriage.

A child on the train is wailing: Muh-mee, Muh-mee. You wonder what this will feel like when your mother has died.

You think: When was the last time I heard a child wailing for their father?

Not listening, not coming, more likely to slap you when he arrives.

A loud little girl on the train says: This is my house and I shutted the front door. I shutted the front door already.

A mother to her child on the train: You got really wet, you did, and who did you see today?

The Tube advertisements are saying:

Will You Survive The Plague?

The Tube advertisements are saying:

Never Stand Still.

Joni was writing Big Yellow Taxi when Bob and the others sang like spit in the eye of soldiers fighting the unjust war.

She performs with the troupe one night when the thunder rolls into town and she rolls on out with them playing Madison Square Garden and Fort Worth.

Joel-Peter Witkin is arranging the leg of woman who survived a train accident on a thick white napkin with grapes, bread and a beautiful fish.

You are watching him on YouTube describing a lesion as looking like caviar. You are feeling slightly faint as your relationship to your body changes momentarily according to these words and you are having to move your toes in bed, trying to bring yourself back together.

You are remembering photographs in a couple of library books, fascinating to you as a child, which showed the aftermath of people who had spontaneously combusted. You are remembering sepia images of charred carpet, the bitter, chemical smell of the pages.

The sky is so beautiful today, the sky is blue, the
afternoon-to-evening sun makes the cladding of the
buildings burnt umber and rose, but you don't feel right,
it is as if you are walking deep in water, you feel heavy
and foggy, muddied, roiling as you walk.

You want sun, you think, as if heat would burn this
feeling off, and repeatedly there is the thought in you
of being gone, away into the sun and of the cool of trees
out of the sun and of warm flagstones. You want to be
out of it for weeks, feeling the flagstones under your feet,
breathing in warmth and light.

Lee Alexander McQueen's last finished collection was called Plato's Atlantis. Two robotic cameras move on runways, filming the audience. This time he wanted everything new; he wanted entirely new shapes. The models are otherworldly, amphibious, post-human.

Lee is sending us back to the ocean, where we will start again.

Outside it is summer; you are in the bathroom at home.
Outside you hear children playing. There is a repeated
banging of construction somewhere as if from a shotgun
and there is a moment of high buzzing as if from a ray
gun and there are children shouting and laughing and
music and then out of the music Joni is singing and
you are crying in the bathroom of your parents' house
because you have listened to Coyote so much writing this
section that what has slid out of sight as Coyote came
centre is that one sentence from Big Yellow Taxi, about
loss and possession, Joni Mitchell has been singing to you
the whole of your life.

[]

You look to your right on the overground to Eltham and on a woman's screen held sideways breaks a beautiful summer wave in shimmering cobalt blue.

Bob says: Life isn't about finding yourself, or finding anything, life is about creating yourself, and creating things.

Perhaps it was Joan Baez dressed as Bob – who can be sure?

DELIVERANCE

When someone dies, it's said, a library burns.

Dear Mum,

Well today we went up the cable car to the top of a
mountain and the snow was about 24 ft deep on the top.
And the view was great. The picture on the front is just
like it was going up the mountain side, the mountain was
about 6,600 ft high and it was terrific, the wind was very
strong and the snow very thick. I have used up about
five films up to now and some of the pictures will be
very good. I hope you are keeping all the post-cards I am
sending you because I would like them in my bedroom
later on.

This morning I saw some deer on the mountain side and
they looked very old. The weather is very good at the
moment and we are staying at a very good Youth Hostel
at the foot of the mountain. Well must go, give my love
to Laura.

Robin x x x x x x x

I am looking at an album of photographs my father took
in winter 1963 on a school trip to Austria. There is my
father on the edge of seventeen, leaning out of a train
window in black-and-white as the wind catches his hair.
There he is sitting in front of a tall log-pile, so handsome
and thin, right leg crossed behind his left knee; holding
a cigarette to his lips with four fingers and his thumb,
looking like a man next to three boys. I turn the pages.
There is a snow-capped mountain; a cable car with
pine trees; black-and-white postcards of the ice-cave at
Dachstein; the charnel house at Hallstatt with two raked
shelves of skulls, names and dates painted on to them
elaborately in black. I used to look at this album when
I was a child sometimes, fascinated by the skulls. Who's
that? I was thinking. Who's there?

I want to tell you more about my father, but honestly I
feel like I hardly knew him. There was always his body
and that was enough. I think that's what makes this so
hard.

A man and a woman are standing on a pier late at night, exhausted. I used to love to look at the ocean, the man is saying, walk by it, just sit and listen to it. Now I don't care if I ever see it again. These young people, I suppose you could say they're a couple, have been dancing in a dance marathon during the Great Depression in America, dancing and dancing day after day for months with short breaks for food and sleep and wild exhausting sprints every so often round a track: the audience turns up because people die or go crazy. In a moment the woman will ask the man, whose name is Robert, to shoot her, out there next to the ocean in the dark. When the police ask him why he killed the woman, whose name is Gloria, his answer is the title of the film: They shoot horses, don't they?

My supervisor recommended it to me as a film about hysteria. A woman sees a man die and she gets into the shower with all her clothes on. When the klaxon sounds to restart the dancing she emits a piercing scream. Someone screamed, she says. A man says: That was you.

Lee McQueen loved They Shoot Horses, Don't They? and he used it as the inspiration for his Spring/ Summer 2004 show Deliverance, fashion show as dance show, choreographed by Michael Clark. There are 1930s-inspired evening gowns; lingerie and Claudine collars; Day-Glo pink trainers in a Parisian dance hall. Things are decaying, things are falling apart, you think it's beautiful but you're watching models being dragged round by the hair. The dress from the start returns at the end in tatters, models and dancers recreating the sprint on the circular track, a dance to death. Come on you salty old bastard, says Gloria in the film with the finish line in sight, holding up an older man dying of a heart attack. Hang on to me! I'm tired of losing.

The final shot of the film is different to the book, returning to the announcer of the dance marathon. Here they are again, he says, these wonderful, wonderful kids [. . .] the clock of fate, the dance of destiny continues, the marathon goes on and on and on and on. He asks: How long can they last?

I think McQueen called it Deliverance after the 1972
John Boorman film about suburban fathers going out
into wild nature: it starts as a canoe trip down a river,
with a man laughing, in fact, interrupted by another man
saying, You want, you wanna, you wanna talk about the
vanishing wilderness? Listen, says the laughing man,
why are you so anxious about this? Because they're
building a dam across the Cahulawassee river — they're
gonna flood a whole valley, Bobby, that's why. Damn
it, they're drowning the river. What finds them out
there on their trip is violence; the murderous, sexual
desires of other men. At the end of the film John Voight
looks out across a wide part of the river, then sideways
through some bushes where men work with diggers on a
graveyard, moving coffins. He wakes up screaming from a
nightmare, a pale hand rising out of the lake.

Our Father, who art in heaven, hallowed be thy name.
Lead us not into temptation, but deliver us from evil.

A child and another child are on a platform of the London Underground (in real life) and one child says to the other: Shall I explain what an avalanche is?

It's like a ginormous, the child says.

A train. When you crash into something.

I'm listening and I'm thinking: Wow.

Another day I am listening to the start of a song and I am trying to describe the sound of something looping, short, perhaps seven or eight times. Maybe what I'm listening to is animal noise or crowd noise (I am trying very hard to make it out), and also there is the sound of something over it, like the echo of many voices in a large open space, a swimming pool or a busy shopping centre. Then there is one voice, possibly a woman's, maybe a man's, who says something only once. First I think I can make out: I want to say good morning. Next I think perhaps the voice says: I want to take all the money. Then the drumming starts, and there is singing. The singing is insistent, trancelike, dangerous.

I am listening and I find myself imagining holding something large in my hand, a weapon, something like a baseball bat or an axe.

On TV this afternoon a woman asks: Finished? She
laughs. The woman says: I thought it will never come to
an end! My life! She laughs again. The woman says: We
definitely – very slight hesitation here before she presses
forwards into – all need a drink? The woman says: OK?
She gets up. She crosses to the left of the screen and
disappears.

The woman is Ma Anand Sheela, speaking at the end
of Wild Wild Country, a 2018 Netflix documentary
series directed by Maclain and Chapman Way, about
the commune she managed at Rajneeshpuram, Wasco
County, Oregon. On 22 July 1986 (eighty-seven days
after the nuclear accident at Chernobyl), Sheela pleaded
guilty to attempted murder and assault for her role in
the Rajneeshee cult's bioterror attack, in which salad bars
in ten restaurants in the area were contaminated with
salmonella and 751 people got food poisoning. She was
sentenced to twenty years in federal prison.

The singers are Fleetwood Mac, at the opening of Tusk,
the title track on their twelfth studio album, released on
12 October 1979. Mick Fleetwood chose the title: it's how
he used to refer to his erect penis. When Stevie Nicks
heard that was going to be the name of the album, she
threatened to quit the band.

I've read a long article about what was left out in Wild Wild Country: life for children in the commune was a horror story of neglect and abuse for the most part; one of the tactics of the cult for making people surrender their ego was agreeing to all sex – women were beaten and gang raped in therapy groups. The article says it wasn't just the salmonella, it says they wanted to spread typhoid fever; that there was a secret project, Moses Five, which sought to weaponise HIV.

Yesterday I watched a video of an armed police officer
pull a member of the public off Usman Khan and shoot
Khan dead on London Bridge. There is the dead body
of Usman Khan, lying on the bridge. The video is shot
from a bus full of people watching, stopped on the bridge.
They are watching John Crilly, standing on the bridge,
spraying Khan with a fire extinguisher, trying to distract
him. Later John Crilly, who served time for murder after
a burglary went wrong, strokes his forehead with his left
hand, rests his left hand on his cheek, rests his thumb on
his earlobe: It seemed like ages before they shot him, he
says, and as I said it wasn't all gung-ho and trigger happy,
they proper took their time, to the point where we, where
I did scream as well, to shoot him.

The member of the public is Darryn Frost, a civil servant
from the Prison and Probation Service, who confronted
Khan on the bridge using a narwhal tusk he grabbed from
the wall in the nearby Fishmongers' Hall, where Khan
had attended a conference on prisoner rehabilitation.

There was nothing sane about Chernobyl, an actor's saying on TV. A woman is saying the same word over and over, over a tannoy. *Nimania, nimania.* Attention, she is saying: mania.

I know you perfectly well, says Hamlet to Polonius, playing mad: You are a fishmonger.

I am thinking of my father after his first breakdown, taking the dogs on the train, he said, so they'd be safe; picking me up from school one day saying he'd been at the opening of a new club for one of his clients and had given Sharon Stone a lift to the airport: could I smell her perfume in the car? What was disturbing was not my father's words but their effect on my mother when I told her, seeing how it knocked her sick.

Hamlet is involved with Polonius' daughter Ophelia. He's vile to her and ends up killing her father. She has a breakdown, drowns in a river.

I get myself into a knot on this page, trying to explain. I'm in a bad mood right now because of the lockdown. Daddy, can't I go out? I'm bored, says Ophelia in Kathy Acker's play Desire. You're keeping me locked up here like I'm a piece of dry goods.

POLONIUS: No, honey, I'd rather you were wet. Do you think I want to see you blackface up your pretty white dress?

That's strange, that thing he says, isn't it – blackface up your pretty white dress.

In the nuclear decay chain, polonium is a daughter isotope of uranium-238. It is intensely radioactive.

HBO's Chernobyl is trying to say something brave and kind about dying for the truth. It uses mostly British actors, their regional accents masquerading as citizens of the USSR. Men are pigs for the most part, Chernobyl seems to say, they redeem themselves with their blood. Women are wise, gentle, overlooked. None more so than Ulana Khomyuk, the fictional Belarusian scientist played by Emily Watson, who is said to represent the many unrecognised scientists, female and male, who stood up for the truth. I think she's also representing, celebrating, the author Svetlana Alexievich, who stitched together an oral history of the disaster, one of several books on Soviet history which won her the Nobel Prize.

Chernobyl is a Hollywood fantasy – Ulana Khomyuk, who everyone is willing to talk to from Gorbachev downwards, for whom every door stands open, every secret unlocks, lighting as she goes a corridor of ordered facts despite the machinery of the entire Communist Party being set up to function in exactly the opposite direction. She is a fantasy but we are not. We're sifting through things right now aren't we? In a small way at least. Not as experts, as ghosts. We can't see everything, no. But give it time and something comes.

John Berger: What is painted survives within the shelter of the painting, within the shelter of the having-been-seen. The *home* of the true painting is this shelter.

Sometime around 1990 I had a history textbook which
covered the Great Plague of London leading up to the
fire. I remember the feeling as I realised plague was
something my body might know how to do, like falling:
accommodation of infection, the knitting together of dark
masses hardening under the skin, commencement of the
process of falling apart. When we got chickenpox as small
children it was different, detached somehow, like noticing
the weather, and more like that when my grandmother
and her sister died as well when I was small: too tired to
play with me; faint stories about dementia and a tumour
between both lungs; my grandmother waving to me from
a window high up in the hospital, the last time I saw her.

In my twenties I was anxious about AIDS and about
meeting the eyes of people acting strangely in public,
as if I was scared of things that might get in. Maybe I'd
changed by the time, in my thirties, I came to open Derek
Jarman's journals about living and dying with HIV while
a friend of mine was dying of cancer. Maybe reading
changed me.

There is a moment in the final journal when Jarman soils
himself in the lift on the way up to his flat, and he and
his beloved clean him up. This is something that happens
to people, I thought as I read.

It was like that when I started reading Alexievich's book
Chernobyl Prayer a few weeks after my father died.
It starts with the body in pain, but as it progresses it
becomes a book about survival, about adaptation and
creativity and faith. She called it a chronicle of the future:
because the plague always comes again, doesn't it?

The decontamination process at Chernobyl began soon
after the explosions – I guess from the moment they
started trying to put the fire out – and will continue
for hundreds of years. The clothes belonging to the fire
crews are still in the basement of the hospital where
they were treated. Then the hospital was abandoned.
Then the city was abandoned. In its way the USSR was
abandoned too. My friend from New York sent me a
wonderful message about this: perestroika, rampant
capitalism and neofascism, he wrote, the state is sold off,
big business moves in, there is deregulation. Then Putin,
some random KGB guy, is appointed, anointed by Yeltsin,
nobody knew who he was, but the nineties were wild,
people wanted certainty, even shit certainty, better than
none, all fine until the oil prices dropped.

At Rajneeshpuram, Wasco County, Oregon, the faithful constructed a city out of the mud. There is a shot at some point in Wild Wild Country, looking out through the window of one of the ruined apex houses of the commune, years after, vast empty plain stretching towards the hills of Oregon.

I remember one of the things that really excited me about getting the internet in the early days of dial-up was MUD, which stood for multi-user dungeon. These were Dungeons and Dragons-esque text-based adventure games you played in a little window, and when you met other users they seemed to be characters in this game. I never actually played one of these MUD games and ended up mainly in chat rooms where the same questions circulated round and round which was age, sex, location and eventually how big your dick was, all of which I lied about. Naked pictures used to download very slowly while I watched them, line by line from top to bottom. Being made to wait was frustrating, but I miss it now sometimes, I miss being so easily overwhelmed.

You are watching a film. There is the very loud sound of rain from the first moment, and we can see the rain hitting water, which on the version you're watching is almost violet, dark static on the water where the rain hits and closer to white where the water catches the light. A woman's voice says something as we watch the rain on the water. She is serious, confident, like the narrator of a public information film, though what she says doesn't seem to make sense.

The woman says: When two people have intercourse there are always four people watching. For it is at moments of great intimacy and vulnerability that the internalised figures from the past become present. But these four ghosts bring along their internalised ghosts and so on, and so on. And this is how the generations going back to the sea-shore, and perhaps before, make their presence known beside us.

This is the voice of Barbara Coles, speaking in Ken McMullen's 1983 film Ghost Dance. She is speaking over the opening shot and later there will be an improvised scene about hauntings with the philosopher Jacques Derrida, during which the phone rings unexpectedly, someone calling from America, and he answers it on-screen. When he has finished speaking on the phone, Derrida says: I believe that ghosts are part of the future. And that the modern technology of images, like cinematography and telecommunication enhances the power of ghosts and their ability to haunt us. In fact it's because I wish to tempt the ghosts out that I agreed to appear in a film. It could perhaps offer both us and them a chance to evoke the ghosts. The ghost of Marx, the ghost of Freud, the ghost of Kafka . . . that American ghost . . . even yours!

Although I don't realise it, I have seen Barbara Coles several times before because she plays a cocooned woman in the Ridley Scott film Aliens, released on 29 August 1986 (125 days after the nuclear accident at Chernobyl).

If you or anyone else in your household has a high temperature, or a new and continuous dry cough, even if those symptoms are mild, says the government information film, you should stay at home.

Bizarre rumours blame the virus on 5G mobile phone signals, tabloid articles make out there are mass graves in London and New York and that people in nursing homes, uncounted for many weeks in the death statistics, are being given lethal injection drugs to keep them out of hospital. The prime minister, absent from the first meeting of COBRA about the virus, and from four subsequent meetings, spends a week in intensive care.

I encounter my patients over the telephone now and online. Now there is a wall of people like water, flowing into the Capitol in Washington, crushing a police officer to death. Watching one video on Twitter, it looks like the cops are waving in the mob; the scenes of violence are published later, a line desperately held. Both sides call the other fascists, both sides talk about the war. Strange times, I find I'm writing often in emails, extraordinary times.

The music video for Tusk makes me think of the first man-made nuclear chain reaction, which took place in a space beneath the west stand of the Stagg Field football stadium at the University of Chicago, on 2 December 1942, the first major achievement of the Manhattan Project.

The word Stagg makes me think of that sonnet by Thomas Wyatt: Whoso list to hunt, he writes, I know where is an hind, but as for me, helas, I may no more. The vain travail hath wearied me so sore, I am of them that farthest cometh behind. Connecting things (in hindsight) can be really exhausting sometimes, don't you think?

A chain and Fleetwood Mac's The Chain. A nuclear chain reaction. A dark line of people, dancing, hand in hand on a hill.

The psychoanalyst Antonino Ferro writes: Through narration, the more connections made between different characters within the field, the less havoc they can wreak.

I am thinking of the ending of Ingmar Bergman's 1957
film The Seventh Seal again, where in the last scene Jof, a
travelling player on his way to Elsinore, watches the main
characters in the distance high up on a ridge, dancing as they
are led away by Death. It's strange how that image keeps
coming back to me, it's not a film I'd say I liked particularly.

Bergman's film sometimes fades dreamily between
scenes, whiting-out a bit like we're passing through cloud
and you don't know how much time has passed, if we've
moved forwards or back. I like the way it makes the
viewer think about artists: in his first scene Jof sees the
Virgin Mary in the field beyond their caravan, holding
the toddler Jesus beneath her by his hands as she teaches
him to walk. We see them too, though Mary looks at Jof
for a moment, not at us. We're inside the artwork along
with them, a little way off to the side like reading, half
in and half out of the madness and the belief. Jof's young
wife Mia is apparently used to hearing tall tales from
him, like when the devil painted their wagon wheels red
using his tail as a paintbrush, but she doesn't seem too
pissed off. The film is so much funnier than I remember
it being (like life, you might say). One night Death
is sawing away at a tree in which an actor is sleeping
and an argument ensues. But I have my performance!
(Cancelled.) My contract! (Cancelled.)

The strict lord Death bids them dance, says Jof, looking to the hillside. He tells them to hold each other's hands and then they must tread the dance in a long row. And first goes the master with his scythe and hourglass, but Skat dangles at the end with his lyre. They dance away from the dawn and it's a solemn dance towards the dark lands, while the rain washes their faces and cleans the salt of the tears from their cheeks.

Mia, smiling: You with your visions and dreams.

The pivotal moment in The Seventh Seal seems to
be about strawberries. It's evening sometime and five
characters are sitting on a rug in the sunlight. The knight
has a suggestion for a different route Mia and Jof can
take to avoid the plague. Mia has picked some wild fruit
from the hill. Smell them, she says and they share them
with some milk. Oh it's so nice, says Mia; for a short
while, says the knight and there's a pause. One worries
so much, says the knight, and Mia says, It's better when
you're in a couple, do you have anyone? The knight talks
about getting married, something belonging to the past,
and he changes the subject, but not completely. Faith is
a heavy burden, he says, it's like loving someone in the
dark who never comes, no matter how you call. But in
saying these words he finds a change has come about,
something about being in the here and now with Mia and
Jof that makes all that seem insignificant. He will carry
this memory with him, he says, as carefully as a bowl of
fresh milk. I'm not sure this is an advert for the healing
power of lactose and good company so much as proof that
what you think will change.

I keep thinking about seals, though, when I think about
The Seventh Seal; I mean about the animals. One of the
things that makes James and me laugh and that we like
to talk about sometimes is Neal McBeal the Navy Seal in
BoJack Horseman, which is set in Hollywood and where
most of the characters are animals walking upright, living
in posh houses and wearing human clothes. Neal McBeal
the Navy Seal is on leave from serving in Afghanistan,
and he gets very angry because BoJack has taken his
muffins in the supermarket, which Neal has put down
for a second (in a pile of apples) while he goes to the
bathroom. I had dibs, says Neal: BoJack doesn't even
want the muffins but Neal annoys him and he refuses to
back down. When Neal gets angry he sort of forgets his
human persona and starts barking. You give me back my
muffins—Arh! Arh! It ends up on the news as a story
about BoJack disrespecting the troops.

I love it when James makes this seal noise. I suppose talking about the scene is a way we make a joke out of feeling angry and wanting to have things for ourselves, something to make that safe. James says I shouldn't put it in the book, he thinks it's just a funny seal. Before the start of the first lockdown we decided the flat wasn't big enough and we'd only end up arguing, so I've been back home for months and I miss him, though we talk on WhatsApp every day, more than we did before, actually. I watch him brushing his teeth sometimes at bedtime and it gives me a funny warm feeling like I get when I've got my arms around him. Arh arh arh. I've just remembered seeing Bergman's production of Ibsen's play Ghosts at the Barbican in London in 2003: I remember the walls of the set being the most insistent, luminous green. In Ghosts, Ibsen writes: The sins of the fathers are visited upon the children. The son in question goes mad at the end from inherited syphilis: Mother, give me the sun, he says, flatly, all expression gone from his face, while his mother panics. The sun, the sun. That's not about seals.

The process of decontamination – I don't know if what
I'm talking about is decontamination at all, really, so
much as the process of how things reveal themselves.
Once you can perceive something as separate you can
separate it off. After Chernobyl this process has an initial
phase where everything seems fine. Messed up but fine,
if you know what I mean. The state of affairs which made
people say: It's just a fire; call the fire brigade. I don't
know what else they were supposed to do. All these bits
of things were on the ground – best clear them away!
And of course they do need clearing away. And then of
course you realise the bits of things used to be inside a
working nuclear reactor and are firing bullets at you all
the time, bullets you can't see, which were also in the soil,
in the tyre treads of vehicles, in the buckets of diggers, in
their rollers and tracks. And, of course, in people. There
was a phase with the firemen where they seemed fine
too. After the burns and the vomiting, with the worst
radiation sickness things calm down and there were
several days during which the firemen could talk and play
cards.

There is a phrase that is used to describe this period of radiation sickness which you may know already, but I find I'm shy of writing down. This is partly because what comes after it is really horrendous: unable to make new cells because its bone marrow has been destroyed, the body starts to fall apart, inside and out, and it's fatal.

They call them walking ghosts.

I am thinking of the sudden beauty of a man's knuckles on the morning Tube, draped over his bag like one of Dalí's melting clocks.

I am watching the ninth episode of Sister Wendy
Beckett's Story of Painting on YouTube. She is talking
about Salvador Dalí.

Dalí's Persistence of Memory (she says in voiceover) is
one of the archetypal images of our century. Everything
we should feel certain of has collapsed and gone berserk.
The melting clocks and the distorted face have an
inescapable intensity. Dalí wants us to be disturbed. And
to enter with him into his nightmare world.

There is a shot of Dalí's Persistence of Memory, melting
clocks and thick dark frame. The head and shoulders of
Sister Wendy move across the shot from left to right
in the habit she designed herself: bandeau, wimple,
black crêpe, her large square glasses. She turns her head
towards the painting respectfully and looks. She turns
back to the right and something happens briefly and
you can see her teeth. It is difficult to capture how she
says what she says in the voiceover – simply, definitive,
without emotion: Horrible painting.

I gave the previous page to my mother to read and she laughed at the end. I said I thought this part was about beauty and violence, and how in the middle of the twentieth century everything got smashed up.

Ah, she says: stop all the clocks.

The year before he wrote his poem Funeral Blues, which starts: Stop all the clocks, Auden, who was homosexual, married Erika Mann so she wouldn't be made stateless by the Nazis; she was the eldest daughter of Thomas Mann who wrote Death in Venice and before her exile she had founded an anti-Nazi cabaret in Berlin. Auden included an early version of the poem in a satyrical, surrealist pageant which takes place around a dying mountain climber in his play The Ascent of F6. A couple called Mr and Mrs A ask questions: Why doesn't my husband love me any more? Why were we born? I had no idea about any of this and I'd never thought of Auden as a left-wing political writer.

This isn't how I know the poem.

I know the poem in the way it's spoken in the Richard
Curtis film Four Weddings and a Funeral, which
climaxes, I guess, with the death of the vibrant gay
character Gareth (played by Simon Callow) during the
third wedding, after which the poem is spoken by his
partner Matthew at the funeral, which was filmed at St
Clement's, West Thurrock, in the improbable shadow
of the red-and-white towers of the Procter and Gamble
plant at Grays. When I was a child the poem was a
doorway into something serious about love and grief, not
satire. I was trying to explain this to my friend earlier.
This Auden poem, and some by Larkin, and maybe
Rhapsody on a Windy Night by T. S. Eliot which ended
up as Memory in Cats, and the Liverpool poets – our love
for these things classes my mother and me in a particular
way. Stop All the Clocks is naff, I thought, Auden is
benzedrine and kitsch, and people writing about middle-
class, regional popular culture and using words like kitsch
and naff is less-than, like Brexit, and less-than is us.

I have been watching a documentary called All Systems
Go! from 1973 about Alan Garner, who wrote The
Weirdstone of Brisingamen, The Owl Service and
Boneland, stories about Cheshire (The Owl Service is set
across the border in Wales, not far away) and violence
and magic. In Boneland, Colin from The Weirdstone of
Brisingamen is a scientist working at the nearby Jodrell
Bank radio telescope, confronting the trauma of the
earlier books with the help of a psychiatrist echoing
the language of Garner's own treatment for manic
depression. Go to the pain, go to where it hurts most and
say whatever it tells you. Alan Garner went to my school;
we both wore owls on our blazers with the motto *sapere
aude*, dare to be wise. Owl-dom is a pun, apparently, on
the name of the school's founder, Hugh Oldham.

I walk up to Alderley Edge where The Weirdstone is
set many times during the spring and summer under
lockdown, listening to YouTube through my headphones,
Alan Garner's forest. Locals just call it the Edge.

Alan says: I grew up in a part of England strong in
magic. It's now called a beauty spot. My childhood was
formed in these woods above the Garner cottage, where
my grandfather Joseph told me the legend of Merlin
who watches with King Arthur under the hill. And I
saw the faces of the legend carved in the rocks by my
grandfather's grandfather, Robert. To go from here into
an urban, academic environment was a shock.

(I'm looking back at this thinking: His grandfather, his
great-great grandfather. Where is his father?)

He says: I went to the people who couldn't let me down,
dead people, and things. Things were not dangerous, trees
and rocks didn't change, dead relatives were safe in parish
records. They stayed put, they didn't demand. But the
unease came back. My trained intellect told me that space
and time were relative, the hills had no permanence, and I
had changed even though the dead hadn't. The result was
the same. It seemed that neither I nor my ancestors knew
our place.

Alan points to an area of the rock of Alderley Edge in which his grandfather Joseph Garner, a locksmith, has carved his name. He spent most of his life in a cellar, says Alan, cutting keys. The sandstone, he says, was part of a desert once only three hundred kilometres north of the equator.

It's still on the move. It's being washed away, and Joseph with it, down back to the sea, to form new mountains in another time and Joseph I s'pose will go with it.

My father is in a metal locker in the garage and it is Boxing Day 2019.

It is 3.10 in the morning, almost two years after my father died. I feel like probably it's too late to do anything with him now, scatter his ashes or whatever, like we've left it too long. Reading over this last sentence days later it occurs to me that I have not said, although it is part of how we really feel, that we have not left it long enough. My father is still too radioactive to move.

There's an owl outside calling, loudly, as I'm typing this. I think it only started a minute or so ago. When owls call like this in the winter, is it about territory or sex?

There is a second owl now, quieter, further away. It's calling back.

It's 3.30 a.m. and I'm reading an article about Garner and violence. This part is near the end:

His memory of sneaking into the cinema as a boy and seeing the footage from Belsen concentration camp, not once but four times, (quoting Alan now) the bulldozer ploughing its graceful hideous choreography into the mass grave, put the world in very real perspective and made him (and then two words, where I hear Garner echoing our school motto, *sapere aude*) violently wise.

In Laurence Rees and Catherine Tatge's documentary
Auschwitz on Netflix, there is a story about the Potts
family from Kent, who travelled to the Channel Islands
in 1939. My mother used to go on holiday as a child there
in the 1950s. The Potts family's nanny, Therese Steiner
had come to England from Austria to avoid persecution.
Wendy Davenport says: It was like having two mothers.
When the family wanted to go back to Kent in the spring
of 1940, authorities in the Channel Islands followed
Home Office guidelines and refused to allow Therese,
then classed as an enemy alien, to leave.

Wendy Davenport says: Although my mother pleaded
with them, they came the next day and took her away.
And in fact we never saw her again. I think there were
anti-Semitic people there, there was, should I tell you,
there was, some, about this man who said to my mother,
If you trail Jewesses about after you, what do you expect?
So she told me. Which is pretty disgusting.

The Germans invaded the Channel Islands in the summer
of 1940. It was the British police on Guernsey who
organised the registration of Jewish people on the island.
Four were registered on Guernsey that autumn, four
on Jersey. Their cards were marked with a red J. In April
1942, Marianne Grunfeld, Auguste Spitz and Therese
Steiner were asked to come to the central police station,
where Police Clerk Sergeant Ernest Plevin asked Therese
to report to the weighbridge at St Peter Port at 7 p.m. on
21 April 1942 (forty-four years and five days before the
nuclear accident at Chernobyl) with warm clothes and
luggage not heavier than she could carry.

Barbara Newman is speaking on the documentary in a turquoise jacket over a cream knit jumper. She says that two of them went down with Therese to the port; that they probably wheeled her luggage on a bike; that they waved to her as she went through the gateway in the barrier, she says: Waving and she went and that was it.

It was all a mystery, she says: Where had she gone, sort of hoped she would come back, but eventually she didn't. It was all outside our experience really, things like that didn't happen in England.

Auguste Spitz, Marianne Grunfeld and Therese Steiner were arrested a few months later in France, part of the roundups of July 1942, and transported to Auschwitz where all three of them died.

I am sobbing, writing this.

I have got myself very upset.

I want to go upstairs to my mother, crying about Therese Steiner, saying goodbye to my father when he was in A&E, assuming he'd be home in a few days, going to London, seeing my patients, preparing a presentation for the training seminar that weekend. I want to say I've had a bad dream.

On the documentary they are playing Arvo Pärt's *Speigel im Speigel*. (Mirror in mirror, that means in English: reflecting and reflecting.)

The German words *Zerfall* and *Zersetzung* are both used in nuclear physics to talk about decay, disintegration, decomposition, dissociation of matter.

Zersetzung was also what Hitler told people Jews did, or Jews were: in his world view Jewish people were the agents of decay within the system, coming from somewhere else, undoing things.

Nature does not know political boundaries. She puts her creatures on to the earth and then waits for the free game of power to play out. The strongest one in spirit and diligence will receive the Lord's position as her most beloved child.

It has been argued this paragraph from Mein Kampf represents Hitler's most fundamental belief. That near the end of his life he pretty much shrugged and said, perhaps I was wrong about Germans being the master race: I guess it wasn't the Germans after all.

Watching the documentary, going upstairs to bed in the dark, I feel frightened. Why am I frightened? As if I'll see a ghost, going upstairs, using my phone as a torch.

If you start thinking things through, this feeling says, thinking about responsibility, something is going to come out of the dark and it will try to get you. If you think too hard, something awful is going to happen. So stop it.

Jung said ghosts are our shadows, the dark things we split off from ourselves.

Ghosts are part of our decay chain.

My mother saw a ghost once, driving with my father in the dark when they were young: a white thing, shapeless, rising from the engine of the car.

Once we were in the basement museum of York Minster one afternoon in winter when the museum was closing and we were the last people there, running to the exit, certain we were about to see Roman soldiers coming through the walls.

There were Blackburns in York from at least the
fourteenth century. John Blackburn of York (son of
Nicholas the Elder) was a member of the council of
twelve and one of the richest and most influential
merchants in the city in the early fifteenth century, and
his namesake John Blackburn the shipman was involved
in transporting the stone with which the Minster was
built. Namesakes who live in the same area make doing
a family tree almost a game of chance once you go back
beyond a certain point: twice I've tried and ended up
in Mirfield in the West Riding of Yorkshire between
Manchester and Leeds, but which Matthew, which
William you chose at particular points, baptised in
Mirfield within a few years of each other, sends you up
a different track, to say nothing of Hannah Blackburn
(1726–1814), whose son William may have been named
after her father and whose own father's name is listed as
Hannah Blackburn in the parish register, about a month
after Hannah Blackburn and James Oldham are married.
Perhaps we weren't meant to be Blackburns at all.

While we are discussing these biographical facts let us
imagine we are standing on the platform of the 6 train
Lexington Avenue line at 116th Street subway station in
the city of New York. In front and to the side of us, huge
murals, in ceramic and glass by Robert Blackburn (born
10 December 1920 in Summit, New Jersey; MacArthur
Fellow, 1992), begun the year after the 11 September
attacks and completed in 2005, two years after his death.
I like how the title of these murals contradicts itself:
Untitled (In Everything There Is a Season). The murals
are in grey-purple blue, and yellow and green. Sometimes
when I'm looking I feel like I'm looking down at the
heads of a crowd, which at other times are eggs or eyes
and fingers of floating weed.

Google says: Some less common occupations for
Americans named Blackburn are cotton-weaver and
housewife. Some less common occupations for Americans
named Blackburn are truck-driver and stenographer.

Agnes Blackburn. Jamaica St Catherine 39. £146 8S 3D.
Seven enslaved. Ellen Blackburn. Jamaica St James 692.
£29 3S 1D. One enslaved. Isaac Blackburn. Grenada 638.
£196 1S 10D. Seven enslaved. John Blackburn. Jamaica St
Catherine 43 (Spanishtown). £148 16S 9D. Nine enslaved.
Jamaica St Catherine 664A and B (Angel's Pen). £1286
10S 6D. 64 enslaved. Jamaica St Thomas-in-the-Vale
24 (Wallens and New Works). £10530 19S 8.5D. 565
enslaved.

I suppose I am not related to Agnes, Ellen, James, Isaac,
John, Peter, Thomas, Isabella in the Legacies of British
Slavery database.

Nor to Robert Blackburn, MacArthur Fellow, who's Black.

Nicholas on to John to Richard to James T. Blackburn
who married Isabol Crompton who gave birth to Thomas,
husband of Jane Boyd who begat John who begat
Humfrey who was alive when Shakespeare wrote Hamlet
who begat Humphrey who married Grace Beaumont
who gave birth to Thomas whose son was William born
the year after the restoration of Charles II and then
Thomas and William and Hannah and William and James
and Joseph, Clementia's husband and then Robert who
married Eliza Booth and George W. who married Kate
Naylor and fathered Robert, who built the Blackburn
Buccaneer which carried the United Kingdom's nuclear
warheads in the 1960s and to Spencer Naylor who
married Laura and was father to William Dennis who
married Marybella, Belle Potter who gave birth to Robin
Bell and then there was Nicholas Robin, which is me.
What if I get married, though, to a man? Would it be like
Hannah, would it make a nonsense of things?

*Kh*atyn! Vladimir says loudly in the car after I've been to
the Museum of the Great Patriotic War in Minsk before
he takes me back to the airport, the end of my visit to
the area of Belarus most contaminated by Chernobyl in
December 2019. He repeats it several times, stressing the
soft-palate, tongue and throat *ha* sound at the beginning
of the word once or twice to teach me: *Kh*atyn! Khatyn
was a village of twenty-six houses and 156 inhabitants,
about thirty kilometres from Minsk, which was burned
by the Nazis on 22 March 1943, along with all but one
of the adults who lived there. It seems that it is still not
clear what happened, not least because partisans don't
wear uniforms. One possibility, my tour guide says, is
that guerrillas were using the village as a base. It snowed,
he says, on 22 March, and so the army would have been
able to follow the partisans' footprints. At least 5,295
settlements were destroyed in this way by the Nazis
as a punishment for collaboration, and over 2 million
Belarusians died (a quarter of the population) in the three
years of occupation.

It is important Vladimir taught me how to say Khatyn because about 380 kilometres from Khatyn, over the border into Russia about halfway between Moscow and Minsk, a memorial complex in the forest at Katyn recalls the massacre of Polish officers and civilians by the NKVD in 1940 on the direct orders of Stalin. Before they were killed they were made to remove their watches and their wedding rings. The Nazis discovered their mass graves in April 1943. For Joseph Goebbels the massacre was a gift: he saw it as a tool to drive a wedge between the Soviets and the Polish government-in-exile as well as between ethnic Poles and Polish Jews in the lead-up to the Nazi assault on the Warsaw ghetto. He described it as: My victory. The Allies, incidentally, accepted the Russian version of events, blaming the Nazis for the killings. There were twenty-two thousand bodies.

I am writing about these two places because the zone
around Chernobyl contained such extraordinary
bloodshed: Stalin killing for the future of Russia, Hitler
killing for control of the black earth of Ukraine. That's
another awful thing about the level of pollution in the
Chernobyl Exclusion Zone; it's such good soil. In 2013
China tried to buy 9 per cent of Ukraine's arable land
– setting the stage, perhaps, for food-related conflict in
the future as our climates change. Ukraine is the fourth
largest exporter of grain in the world.

Also my mother's name is Kathryn.

Corium – a word I've always liked – is the lava-like
mass that's left over when a reactor core melts down,
literally melts (literally downwards), the molten uranium
merging with molten concrete, sand, serpentinite
shielding in the wall of the reactor and whatever else
the containment vessel is made of. There are corium
stalactites under the Chernobyl reactor, and frozen
waterfalls of dark, highly radioactive metal and concrete,
and on the floor of one of the rooms down there is a
large, grey, intensely deadly mass which looks like an
elephant's foot. Spend minutes near that, even now, and
you're dead.

Given I started this section with Tusk, it's remiss of me
not to have mentioned the Elephant's Foot as part of the
story of the Chernobyl decontamination – though again
I find what I'm describing is the things that are hardest
to decontaminate. Some things just have to be left where
they are, and what you have to do is stabilise the building
so it leaves them where they are too (elephants never
forget), and you do what you can so as things don't leach
downwards, get into the groundwater and explode or
poison everything.

A friend's partner left him just before Christmas: I wonder if his job, administering doses of the Covid vaccine, makes this easier or harder. In his Instagram Stories he's posted a video of a woman of colour in sunglasses driving a station wagon until her face is at the centre of the shot. Closure, she says, is just you wanting a verbal explanation for something they've already showed you. She smiles before she drives away: Move on!

I'm watching an interview with the Ukrainian boxer
Vasyl Lomachenko. It's like in a . . . er . . . car breaks
down, he is saying, the same situation with our body.
Only people who are around boxing, they understand.

He is being asked about the death of a man they call his
stablemate, Maxim Dadashev.

I watch as Lomachenko touches a place between his
shoulder-blades, below his neck. I can't tell from the video
what he is in touch with; whether his fourth finger and
his third finger are in contact with one of the hard edges
of bone in his spine or the edge of the muscle in one of
his shoulders. I'm thinking of the way you're supposed
to use the ball of muscle below your thumb as a guide, in
order to judge how well a steak has been cooked.

[Dad]ashev.

I spar with him, he says, he was in my house.

From the diary of Derek Jarman, Tuesday 26 January 1993:

It's three years today since I witnessed the nuclear power station blow its top – HB rang to say the diary entry was reproduced in the Independent.

Three years earlier:

Deep in the night HB had a boxing dream and punched the pillow next to my face so hard I felt it coming in my sleep. He missed me by a hair's breadth. I found myself shouting, What the fuck did you do that for?

Derek Jarman, artist and filmmaker, was diagnosed
with HIV in December 1986. That summer he and the
actress Tilda Swinton had visited a remote wilderness
which would become the location for several of his films.
He would return there, buy and renovate a Victorian
fisherman's hut, called Prospect Cottage.

I took my Super 8 with me and one shot from that day,
my shadow racing across the sand, ended up in The Last
of England. On the horizon we could see the nuclear
power station at Dungeness, marked by a thin plume of
black smoke. Was that sunlight contaminated? At that
moment in Chernobyl the doom-watch ticked. A week
before Tilda and I had walked in the teeming rain in
Glasgow; radioactive rain, we joked, and of course it was.
Driving back home from Camber Sands I dreamt up a
little lead-lined house, The Villa Chernobyl, a Geiger-
counter ticking in the hall where the grandfather clock
used to chime away the hours. A villa remote in time and
place, visited by foolhardy adventurers who braved the
desert landscape for tea and scones.

In the summer of 1986 (writes Jarman) my father
had a stroke which left him with no speech and little
movement. By a miracle his character changed. When I
arrived at his bedside in Southampton General Hospital
he broke into a radiant smile.

The following page is a black-and-white photograph of a
mushroom cloud with the caption: My father attends a
dress rehearsal 1953. There is a large crowd of soldiers in
a line about an inch from the bottom of the image, which
is scrubland, two helmed soldiers in the foreground to
the right. I think it must have been taken at Emu Field
in South Australia, where tests were carried out for a
British atom bomb as part of Operation Totem in October
1953. The bombs were called Blue Danube, Modified
Blue Danube. I have a German poster on my consulting
room wall for Pasolini's film Saló, which reads: art, music,
poetry, design, do nothing to humanise society.

Blue Danube. Modified Blue Danube. It just blows my
mind they called them that.

Jarman's father was an RAF pilot during the Second
World War; you see film of him in The Last of England.
He writes that his father was disgustingly fit: he sailed
for the RAF, taught astro-navigation, was an examiner
for the master mariner's certificate; at seventy he would
take out an ocean-going yacht in a howling gale with a
crew of young men in their twenties, and return after
a couple of days bright as a berry with all the boys
exhausted. From dawn to dusk he would be chopping
wood, dismantling cars.

In a radio interview with the psychiatrist Anthony Clare, Jarman is talking about his mother's death.

It was a disaster because he ran away, you see, and I got terribly upset and we, we had to virtually force him back into the hospital really to say goodbye to her. It was my sister and myself who held my mother's hand as she died, not my father. (Clare: Where was he?) He was in the other room. He couldn't face it. (Clare: Do you recognise anything of yourself in him?) Oh a lot, a great deal. I resemble him almost more than my mother now at this stage of my life, probably the tone of my voice or something, I see there. I see more of him there than I do of my mother. There's a certain isolation in my life as well which I think is similar to his but I'm not a person who closes the door so easily on people.

A friend is at Prospect Cottage and messages me a photo she's just taken of Jarman's desk. It seems like things are still as he left them with some of his lover Keith Collins' belongings there too.

Dungeness is a place with no fences or boundaries; I found that rather alarming when I visited. Where are you allowed to walk? Looming in the background of the cottage there is reactor B of Dungeness Nuclear Power Station, close to the sea.

Collins is called HB (Hinney Beast) in Jarman's diaries, which end with the words HB true love, shortly before Jarman's death from an AIDS-related illness in February 1994. Collins died of a brain tumour on 2 September 2018. He was only two years older than Jarman had been.

EMPRESS NAGASAKI

From The Last of England:

They say the ice age is coming. The weather's changed.
(Silver-grey Super 8 film of Jarman writing in Phoenix
House off the Charing Cross Road in London, late at
night, intercut with red film of a young man whose name
is Spring, walking towards the camera at knee-height.
Spring's getting ready to shoot heroin, Spring is kicking
and masturbating over a copy of a Caravaggio painting:
Spring is rose-tinted, blood-stained.) The air stutters tic
tic tic tic, rattle of death-watch beetle on the sad slate
roofs. The ice in your glass is radioactive, Johnny!

The lady next door to me says

THERE HE IS! THERE'S HIROHITO

AND HIS EMPRESS NAGASAKI

Look! Johnny look!

In the photo is a brown table, on which are four
hardbacks of different sizes, first a thin white book with
a label I can't read. Richard Rhodes, The Making of the
Atomic Bomb (thick, black with silver title). Nevil Shute,
On the Beach (salmon, black title). Wilfred Burchett,
Shadows of Hiroshima (white with black title). This
topmost book is bookmarked using a bright blue folded
piece of card with black lettering, some words lost in
the folds: it's part of a protest leaflet against trains
transporting nuclear material on the passenger network.
Only part of it is visible.

NUCLEAR

Trains like the one shown

These trains carry highly

accident, these could rele

I think that last word must be release.

Jarman's diary records a controlled emergency shutdown of Dungeness A, at 3 p.m. on Friday 26 January 1990, due to lightning striking power lines. Jarman writes: The nuclear power station exploded in a roar of steam, which drifted over the Ness – a death rattle like a hundred jet planes taking off. Within seconds the enormous building vanished from view; sparks flashed in dark clouds.

On Wednesday 8 May 1990, Jarman wrote:

Mist drifts over the towers of the nuclear power station like a steam kettle. I miss HB – who danced about threatening to cover himself with tattoos of lizards, which he spent time hunting in the garden.

It was barely spring when I first went to Dungeness and I didn't have the courage to go up the path to Prospect Cottage. On the drive home there was a violent downpour and the windscreen wipers failed.

19 April:

Long walk to the west of the nuclear power plant, lit by shafts of sunlight under an angry slate sky.

HB is dancing and pressure is building like a steam kettle.
Pressure is building and bringing down buildings, like
Freddie Mercury sings in Under Pressure by Queen and
David Bowie sings with him at Live Aid and with Annie
Lennox after Mercury dies of AIDS on 24 November
1991 (five years, 182 days after the nuclear accident at
Chernobyl). Mercury barometers, measuring pressure:
and all I feel is pressure, David Wojnarowicz is shouting
louder and louder in the white gallery space in New York
as AIDS deaths rack up and flowers wrapped in plastic
fall in front of the 1986 tombstone information film,
directed by Nicolas Roeg director of Don't Look Now
– and mourning becomes the law – and love is the law –
and all I feel is pressure and the need for release. Freddie
and Derek and David and David, dead good-looking in
beauty's summer and all dead (and my dad dead) long
line of people look Johnny don't look now fuck me blind
against a white sky darkening dancing the blues in their
red shoes dancing the Totentanz in the fallout in this
fallen world and the planes bringing their bombs and the
towers burn: Babel and the Twin Towers and Grenfell
Tower.

Marco is dancing and Gloria and Raymond known as
Moses to friends, who lived on the twenty-third floor, and
Fethia and Hania and Rania and Hesham and Mohamed
and Fathia and Abufars. Isra and Zainab and Mierna
and Fatima and Bassem, Nadia, Sirria, Firdaws, Yaqub
and Yahya and Hashim. Nura, Anthony, Mariem, Eslah,
Ligaya. Mehdi is dancing (he's small, he's only eight),
dancing with his parents, his older brother and his sister:
Nur Huda, Yasin, Faouzia, Abdulaziz. Mary is dancing,
with her daughter Khadija Saye, the photographer. Malak
and Leena and Farah and Omar, Jessica and Gary and
Deborah and Ernie and his mother Marjorie with such a
fine white hat. Mohamednur and Amal with Amaya in
her arms and there's Amna and Fatemeh, Sakineh, Isaac,
Hamid, Biruk, Berkti, Vincent, Mohammed, Mohammed
and Husna and Rabeyah, Kamru and Khadija and Joseph,
Sheila and Steven, Denis and Mohammed and Jeremiah
with Zainab. Abdeslam and Ali and Victoria, Alexandra.
There is Logan, dancing in the womb and Maria is
dancing because if they aren't dancing, if they're dead,
how can we go on with it, how can we look one another
in the face?

Julie Walters is telling Billy Elliot the story of Swan
Lake and you're watching drunk on a plane, thinking
how it's a film about sexuality and the miners' strike and
James is saying: You can't just write down the film of
Billy Elliot and put it in the book, and you write: James
says there's nothing the miners' strike and Chernobyl
have in common. Billy Elliot is dancing. Billy Elliot is
walking forward in his boxing gloves and boxing shoes
like Maxim Dadashev and Billy is reflected in the mirror
like Alice through the looking glass and Hold it, says Julie
Walters as the dance teacher, hold it. What is being done
to the women in this film? – mother dead and Walters as
the dying swan and Billy's leaving, her teaching the boy
how to be a man and her daughter saying, I'll show you
my fanny, and Billy saying, Nah, you're all right. Hannah
Arendt writes: Terror can rule absolutely only over men
who are isolated against each other. James is watching
Red Joan and is holding your index finger quite tightly in
his curled hand and it makes you want to cry.

Billy Elliot is dancing to Cosmic Dancer by T-Rex where womb rhymes with tomb. Billy Elliot is dancing and Old Tom Eliot is dancing with Viv and Valerie on Margate Sands and Billie Whitelaw mouth-dancing Beckett's Not I, Billie Piper dance-buzzing heaven's buzzer at the start of Honey to the Bee, Eve Libertine dance-speaking punk band Crass's Reality Asylum, railing at Christ for allowing the bombs, the camps and Christ is a goat she says, calling him Billy, and she's naming Treblinka, Hiroshima, horror on horror, and every woman is a cross, every man is a kid with a knife radiating colonial splendour like the anti-flash of Robert Blackburn's Buccaneer low-level subsonic strike aircraft in the Cold War, white to bounce thermal radiation from a nuclear blast and then fly home to ashes. Will telling set us free, do we imagine, in therapy, on trial, at the pearly gates? Tell it to your dad, son, why the sad face? I see oceans of bodies, father, dropping like the petals of flowers, falling softly like plastic falling through black water to the bed of the ocean. Once in the playground, when a teacher called me to be told off, I thought that if I closed my eyes he wouldn't find me. I remember the sensation of it in the dark, with my eyes closed, winding through the playground for ages as the teacher called my name. Billy says that: when I'm dancing, I sort of disappear.

Three-quarters of the way through their song They've
Got a Bomb, Crass stop playing for nine seconds, and
at this point during live performances they turn the
lights out and play a film of a nuclear bomb exploding:
a moment of silence amongst the noise and the dancing
like a blank space on a page, in which to consider the
reality of nuclear war.

We take an overnight ferry to Holland and as we wake at dawn it is all there before us, framed by the cabin window, this perfect O of rose light and flat water, as we come into ourselves.

I am thinking of a poem by Kathryn Simmonds my friend found among her papers and sent me, called Elegy for the Living.

While I was getting ready to go to Chernobyl, I found an extraordinary book by Arthur Chichester called The Burning Edge, about the time he spent travelling in the area of the Belarus most affected by the disaster. The book also gives a sense of being a relatively wealthy, heterosexual British man in the country where his loneliness comes up against young women's longing to get out of Belarus via marriage. Almost everyone he encountered called President Lukashenko *batka*, meaning father.

Chichester is on a green trolleybus in Gomel and he sees a man on the bus who is clutching a length of rope.

Chichester writes:

When our eyes met across the tops of the seats he stared back confrontationally, challenging me to look away.

I don't know why exactly but something told me there was an air of desperation about him.

He disembarked at a stop that stood on the edge of the forest, somewhere deep in the suburbs of the city where concrete and nature collided abruptly and for some reason I felt compelled to follow him.

Arthur follows him into the forest. The man knows he is being followed but continues, turning off the path into the birch trees and the mud. Eventually their eyes meet. Arthur steps forward to say something, but the man turns away, goes back to the bus stop and gets on a bus.

He was wearing eye make-up, tight jeans and a fun
fur jacket, when Deborah Curtis first met her husband
Ian, who would become lead singer of a band called
Joy Division, named after the sexual slavery wing of a
concentration camp in the Hebrew novel House of Dolls.
Ian died at home in Macclesfield, about an hour's walk
from our house on 18 May 1980: suicide by hanging, he
was only twenty-three.

I love the names of the reggae clubs Deborah speaks
about in Manchester in the 1970s: the Mayflower, the
Afrique.

Ian says: I think in the beginning it was just something we wanted to do, you know, just to get up there and play. But, after about six months or so we started looking at the music, what we wanted to say more seriously.

Ian says: I'd like to say the music we play cuts across different things.

Deborah and Ian lived with her grandparents for a time. Moving back from Oldham to Macclesfield, they decorated Ian's work room first. I don't want to paint a one-colour portrait of their lives: they were young, outgoing people, I'm sure there was a lot of laughter in that house. I'm reading about their Irish family history; his father's service in the Second World War; Deborah being upset as the relationship floundered and she read the words *your* bedroom turn to *this* bedroom turn to *the* bedroom in Ian's revisions to the lyrics of Love Will Tear Us Apart.

Remembering a conversation they had one day, Deborah writes: I didn't understand why he wanted to talk about a local boy who was said to be suffering from manic depression; it seemed like gossip and was uncharacteristic of him. He explained any of his own unusual behaviour, absences or seizures as flashbacks and it was made clear they were not up for discussion.

Ian was suffering from epilepsy: it's not clear what triggered it, though he drank alcohol before performing and performances were noisy, there were bright, flashing lights. The medication he needed to take would have influenced his mood. Faced with a problem he couldn't deal with, Ian would explode.

The sudden onset of very strong seizures must have been horrendous for Ian Curtis and for everyone around him. Couldn't pick his daughter up, says Bernard Sumner, couldn't drive a car. Had to be careful at railway stations that he didn't stand too near the edge.

Imagine listening to someone playing six notes on a guitar and hearing in that rhythm a space for the five words: love will tear us apart. What must that be like?

I am thinking about the words: a space, about making spaces in the pages of this book, allowing them to fill up and to empty out again, like breathing, like the space left by my father when he died and there was no longer the presence of his body to make up for an absence of speech.

We need the empty spaces of the mouth and throat to speak: the gap between the lips, the spaces of the lungs, the supra- and super-glottal cavities, the narrow slit of the glottis between the vocal folds in the larynx of the throat. When air from the lungs is pressed through this channel it starts to vibrate.

One of the dreadfully sad things about the moment Ian Curtis, a singer, places a washing line around his neck is how it closes off the space for something to be said.

There were these two people that were Ian Curtis, someone is saying on TV: the one that was the media figure and the singer in the band, and the actual Ian Curtis that was hurt, angry, lost, very lonely, and didn't think that people would treat him with respect if he explained who he really was. This is Genesis Breyer P-Orridge speaking (headshot: dark background, blonde wig, red lips), of COUM Transmissions and the bands Throbbing Gristle and Psychic TV, who collaborated with Derek Jarman in the 1980s and was the last person who spoke to Ian Curtis on the telephone the night he died. The thing is I don't think Genesis believed in an actual, singular person. This was an artist who changed names and bodies, whose many aspects included musician, shaman, cult leader, parent, lover, aggressor. We started out (Genesis on their second marriage to Lady Jaye, who worked as a dominatrix and a children's nurse in New York), because we were so crazy in love, just wanting to eat each other up, to become each other and become one. And as we did that, we started to see that it was affecting us in ways that we didn't expect.

Ian Curtis, David Bowie and Genesis P-Orridge all shared
an interest in the cut-up writing method of Brion Gysin
and William S. Burroughs, who noticed that one way
to get towards something profound is to cut up what
you've made into pieces and sew them back together in
a different order. I'm not sure any one Ian's more valid
than the next: Ian the singer, the poet, the young father,
the lad. His different relationships, his performances,
are rather a meeting of authors in search of an Ian. A
person is always in the process of becoming a character,
an infinite process which draws me to the concept of an I
with no borders, no divisions, something we do not quite
have language for. I was looking at Curtis' lyrics earlier
for repeated words and the one that does stand out for me
is the word: this. I think writing this is one way he tries
to get a grip on something, only I'm not sure you can
always; I'm not sure much of this is really ours.

Joy Division played their instruments too loud for his
bandmates to hear the lyrics anyhow.

Bernard Sumner tells a story on Grant Gee's documentary, Joy Division, about how, after the band played a concert in Bournemouth one night and they were walking back to their boarding house after a drink at the Buzzcocks' hotel, Ian suddenly turned off into the darkness and began walking out into the sea and they had to go (I think he means actually into the water) and get him.

I am watching a video of Ian Curtis singing at Bowdon Vale Youth Club in front of green flock wallpaper; there is a transcendent expression on his face, beautiful, gone, like a drowned man; he is dancing like someone dipping their head underwater. They called the Joy Division movie Control but art is just as much about surrender.

I am thinking of two lines by the poet Stevie Smith; of being far from shore, out of my depth and the waves rising around me.

In Jon Savage's review of Joy Division's Unknown
Pleasures in Melody Maker, a year before Curtis'
suicide, the first paragraph reads: To talk of life today
is like talking of rope in the house of a hanged man.
Where will it end? The point is so obvious. It's been
made time and time again. So often that it's a truism, if
not a cliché. Cry wolf, yet again. At the time of writing,
our very own mode of (Western, advanced, techno-)
capitalism is slipping down the slope to its terminal
phase: critical mass. Things fall apart. The cracks get
wider: more paper is used, with increasing ingenuity,
to cover them. Madness implodes, as people are slowly
crushed, or, perhaps worse, help in crushing others. The
abyss beckons: nevertheless, a febrile momentum keeps
the train on the tracks. The question that lies behind the
analysis (should, of course, you agree) is what action can
anyone take?

Towards the end of his life Curtis became romantically involved with Annik Honoré, a music promoter, who started working as a secretary in the Belgian embassy in London in 1979. She says:

It was a completely pure and platonic relationship, very childish, very chaste. . . I did not have a sexual relationship with Ian, he was on medication, which rendered it a non-physical relationship. I am so fed up that people question my word or his: people can say whatever they want, but I am the only person to have his letters.

In Grant Gee's documentary, Annik says: You know he
was something, some light burning inside him. It's there
in a screenshot I've taken of him singing. His burning
eyes.

Trying to find Annik's words so I could write them down,
I google a phrase and it takes me to a page of phrases
in English and French also containing the word light. I
am reading this page in bed, thinking about Ian Curtis
and the firemen who died of radiation sickness after
Chernobyl.

Svetlana Alexievich's story about the firefighter Vasily
Ignatenko and his wife Lyudmilla, taken from a recording
of Lyudmilla's words, is about the collision between two
young people who love each other and the power of a
catastrophic accident. It is a religious story in the sense
that it contrasts the fragility of the body with immense
strength of feeling. Vasily had become so swollen by the
time he died they had to cut up the formalwear to get it
round him, bury him without shoes. Against all advice
Lyudmilla stayed close by him until the end.

The presence of alcohol causes a light burning sensation as in the application of iodine. *La présence d'alcool provoque une légère sensation de brûlure comme lors de l'application d'iode.* You know, he was something . . . some light burning inside him. *Une flamme brûlait au fond de lui.* We keep the light burning at night so he won't be afraid. *On allume la lumière pour qu'il n'ait pas peur la nuit.*

Iodine tablets protect you from cancer after nuclear
accidents in a peculiarly mechanical way. Your thyroid
gland is in your neck, made of two connected lobes.
It does all sorts of things: regulating growth and
development in children and in adults metabolic rate,
protein synthesis and the way calcium is processed.
Nuclear accidents at Chernobyl, Fukushima, Kyshtym
and Windscale all released radioactive iodine-131, which
has a half-life of about eight days. Potassium iodide is
a non-radioactive salt which can be used to saturate the
thyroid gland so it can't absorb iodine-131. You kind of
just fill it up with iodine in advance so the radioactive
material can't get in.

I find Annik again on a page of words in English and
Spanish, a list of ways of using the phrase *por dentro,*
inside. Most of the examples are about burning. *Nos
calmaríamos de los fuegos que nos estaban quemando
por dentro.* We would cool off from the fires that were
burning within us. *Me pongo enferma después de cada
comida siento como si me estuviera quemando por
dentro.* I'm sick after nearly every meal, and I get this
burning pain all down here. *Hay una pregunta que me
ha estado quemando por dentro.* There's a question that's
been burning inside of me.

Later, in Portuguese: I know he was something . . .
some light burning inside him. *Era uma coisa, uma luz
quiemava no interior.* A flashlight is burning inside my
heart. *Uma fogueira queima dentro do meu coração.*

I am thinking of another story about a nuclear accident.
It happened in Brazil, where the official language is
Portuguese, 505 days after the explosions at Chernobyl.
Roberto dos Santos Alves is twenty-four years old. He
is a trash-picker, walking the streets dragging a large
wooden cart. On a busy street-corner not far from the
airport he comes upon an empty lot covered with rubbish
and weeds, and there in an abandoned building he finds a
machine which looks like a valuable source of scrap metal.
Roberto gets his friend Wagner Mota Pereira and they
put the inner part of the machine into a wheelbarrow and
take it to Roberto's backyard, where they place it on a
brown rug and start smashing it to pieces with hammers.
It is 13 September 1987. By the evening both men are
being sick, but they don't stop their work.

The next day Wagner has diarrhoea. He has a burn on his hand, which is swollen, the shape of which corresponds to an area of the machine assembly like the closed aperture of a camera. Later, in hospital, people wearing protective clothing will have to amputate parts of several of his fingers and Roberto's right forearm. On 15 September, Wagner goes to a local clinic where he's told he's eaten something nasty and must go home and rest.

The following day, using a screwdriver, Roberto manages to open a small hole in the aperture part of the assembly, out of which begins to shine a deep blue light. He scoops out some of the substance with the screwdriver. He is now in direct contact with the caesium chloride source of a radiotherapy machine with a dose-rate one metre from the source of 4.56 grays per hour. Exposure to 5 grays of ionising radiation usually causes death in a fortnight (Vasily Ignatenko's dose at Chernobyl is thought to have been about 14 grays). Thinking the substance he's discovered is a type of gunpowder, Roberto tries unsuccessfully to set it on fire.

On 18 September, Roberto sells what he's found to a scrapyard owner called Devair Alves Ferreira, who notices the blue glow coming from the hole in the capsule, which he brings into his house. One in a long line of people who have taken nuclear material to be expensive and possessed of entrancing supernatural power, Devair begins showing the substance to his family and friends. He receives a dose of about 7 grays of radiation but survives until 1994, dying of cirrhosis aggravated by depression and binge-drinking. Devair shows the substance to his brother Ivo who spreads some of it on the concrete floor where his six-year-old daughter Leide is playing and eating a sandwich. Caesium chloride gets into what she's eating and it burns her from the inside. Leide (6 grays), Devair's wife Gabriela (5.7 grays) and two of Devair's employees, Admilson (5.3 grays) and Israel (4.5 grays) all died.

There was a riot of at the cemetery the day they buried Leide: two thousand people, frightened she would poison the land.

I am thinking of Ian Curtis and Lee Alexander McQueen,
of Leide das Neves Ferreira, Gabriela Maria Ferreira,
Admilson Alves de Souza, Israel Baptista dos Santos,
people who don't stop, don't know they'll get burnt, who
don't leave the bright thing, the fire, the magic, alone.
Start writing the first words that come to your mind, says
the Spanish phrase list, whatever is burning inside you.
Por dentro. He's burning up from the inside. His eyes
were burning into me. Something burning inside. It's
all charred on the inside. That was what I was burning
inside with. You know, he was something . . . some light
burning inside him. They were burning inside . . . but
they just kept holding on. Was it because you wanted me
and it burned inside of you? Winter was cold, but burned
me on the inside, it was a winter blaze. When I hear your
voice early in the morning, it gives me a great kick, if I
don't talk to you at least once, I'm on fire from inside . . .
Father!

The air is strange this afternoon. There is a match on at the Oval and occasionally it fills with the hiss and rush of score reactions. Later there will be rain. It's a heavy day for air pollution and near the park I'm hearing it stick in people's throats: sharp stop of a cough, or sneezing. The clouds are a purplish grey.

The director John Maybury is sharing short clips of Quentin Crisp on Instagram. Quentin says: When I was young I didn't really have any very strong ambitions. At a time when my two brothers wanted to be icons of manliness, they wanted to be firemen and the captains of ships, I wanted to be a chronic invalid.

Quentin's hair is purple too. Purplue.

John Keats died in February 1821, leaving instructions his tombstone should read: Here lies one whose name was writ in water.

Australia is burning as I'm writing this. Someone on Twitter said that if you laid out the fire front across Europe it would stretch from London to Moscow. At least thirty people have been killed and thirty-three wounded in an airstrike on a military school in the Libyan capital, Tripoli. I think America is going to go to war with Iran.

The novelist Michael Cunningham is posting short, close-up videos of the ocean on his Instagram, squares of water, blue-grey, brown-green, grey-blue.

A filmmaker I recognise is arrested for fucking on a Tube train for an online porn site. I remember seeing him at the ponds in Hampstead last summer.

There is a man on the train next to me listening to music, swiping with the index finger of his right hand, pointing and swiping as if he's cancelling dates.

Young queens of colour talking by the men's bathing pond saying, Ooh the wind. Holding out a plastic cup for wine saying, Fuck me up. Planning Annabel's or oysters at The Curtain. Wanting: Just a little drisé (perhaps I misheard this).

In the water in the men's pond, brushing past my arm, is a single long stem upon which swims a brown leaf.

I am teaching and my student says he is afraid of the ocean.

He draws it for me, shading its depth thickly in black biro.

He tells me that a few days ago there was a murder involving two boys at his school. He tells me the most horrendous thing. And then he says: And we went to the football and it was horrible.

He says: It's toxic when it's not going well.

He says: It gets really bad.

He says: People don't want to stay.

He says: Upton Park.

It's not fixable.

It's not a football stadium.

It's all white seats, no claret.

I am thinking of the seats, the claret.

When Theresa May is photographed at the time of
her leaving office, after the brutal process of failure to
negotiate with her party, her crying face on the front
page is something unwelcome, like she has been forced
to strip. There is no compassionate critical distance here,
it's either drought or flood, trauma comes upon trauma in
great waves. These are tears that salt the earth.

I am afraid there will be violence on the streets.

A handbag, open on the ground next to Climate
Emergency protestors, makes me anxious about bombs.

Whaley Bridge

Toddbrook Reservoir in Derbyshire, a short drive from
the house, may be about to burst. I am taking a taxi back
home from Macclesfield Station and the driver is telling
me what local people have been saying.

Todd is from the Middle English word for fox, I think: I
say this having just corrected this page, when what I saw
before was *toden* (deaths, in German); *Totentanz* (the
dance of death).

He tells me about pets left in houses at Whaley Bridge;
an old woman crying, asking to be let back in by police;
the army putting on sand and gravel at 5 a.m., like
Chernobyl.

You push a little more power into Atlanta, a man says
at the start of Deliverance, little more air conditioners
for your smug little suburb and you know what's gonna
happen we're gonna rape this whole goddamn landscape. I
don't believe in insurance, says Burt Reynolds, there's no
risk. You just wait till you feel that white water under ya,
Bobby. Back in time to see the pompom girls at half time.
Sometimes you have to lose yourself, Burt Reynolds is
saying, before you can find anything.

The taxi driver looks at me in his rear-view mirror. On
the radio the Hollies are singing their song The Air That
I Breathe. It's all gonna go, he says. He talks about the
Mercy of God.

In her play Desire, Kathy Acker writes about a three-foot wide rivulet of black water, flowing, now stagnant, against cobblestones, each one slightly apart from the ones surrounding it. Toward the back of the street near an uneven light grey sidewalk, smaller black pools obscure the stones.

For some reason her last sentence sticks in my mind: The more rapidly the water moves, she writes, the lighter it seems.

In Deliverance, Drew is paddling down the rapids with no life jacket on. He seems disoriented. Something's wrong, his friend says, and Drew pitches – it's unclear if he dives or falls into the water.

Now John Voight is screaming and falling, now he's in the water with a dead man like they're dancing, grappling, two men, one of them a corpse, in the bubbles, in the green water and the golden light, ropes snaking around them.

Right there's the town hall, says the man who is driving the survivors out of town. And over there's the old fire station. Laid a lot of checkers over there, sure did. All this land gone be covered with water. Best thing ever happened to this town.

washing over me

I am in the pub in Eltham and Carole King is washing over me.

There is this strange feeling in my chest that makes me think of panic attacks, two weeks of being over my overdraft in the bank, chest full of hot water like I might cry or fall over.

Much easier not to write about a feeling that feels like nothing, I write into my phone on the bus one day. Like being full of nothing? What is this feeling like? I feel it a lot. When I press it in this way it turns into an angry feeling; has it been that all along? It aches, inside, but it does not hurt. It is not hungry like a bored feeling, though I am bored of feeling this way. It's a feeling, not of waiting for something to happen, like boredom, but of the numbing of possibility. I wouldn't care if anything happened and I cannot imagine doing anything well. Is it the sad reaction, like a bruise, to knowing that going out tonight and getting drunk and being with people who don't know me will make me feel better . . . or is that the feeling itself? That something about where I am now is wrong, and distracting myself from it is easy, and I can do this until the money runs out, or until I die, whichever is sooner. Being flawed, and lonely – feeling oneself being erased, like sand that blows across a piece of paper, and all the things one can think of to counter this are stupid, are really stupid things to do.

Her dead friend

The lady opposite me on the train is talking to her friend. Her dead friend keeps coming up on Facebook, she says; she keeps forgetting that she's dead. She says that her friend's husband has taken over the profile, he is using it to keep people up to date.

I dream my Uncle Peter visits, shows me a photograph
of someone I don't recognise, who he says is his dead son
Trippier. He excuses himself (not feeling well), after I say:
I can't imagine what that must have been like for you.

In therapy I talk about this strange name, Trippier
(tripping up, tripping out), which sounds to me like
Pripyat, the abandoned city near Chernobyl.

I dream I see my uncle in a crowd somewhere; I call to
him. There are too many people; I don't catch him up.

I dream I am a nuclear technician, carrying in her hands circuits from the damaged reactor. They are thick boards, stacked together like a book. I am outside but I want to keep them safe. It is all waste ground, brown and ochre and grey under a grey sky. Now I am inside, next to a bookcase in a suburban house in the North-West of England, trying to put the circuits in amongst the photo albums. I know the circuits can't be kept secret because they are radioactive. I know soon the authorities will come and they will take them away.

I am on the train again. In the wake of the prime minister's resignation, things at Westminster are all happening very fast and there is no sense of what will happen by the end of the day. I am thinking of Sebastian Pons talking in the Alexander McQueen documentary about his father seeing McQueen's Horn of Plenty show opening the evening news – the trash, the monstrous figures – and saying to him: I think your friend has gone really mad.

Twitter tells me about a man I don't know, watching a man who works for the Greggs bakery in Manchester, chasing another man through Piccadilly Gardens who has stolen a baguette. The man is shouting: I hope you fucking choke on it.

During the UK election campaign there is much discussion of each candidate's willingness to press the nuclear button.

There is a laptop advert selling how well this particular laptop's battery keeps its charge. People (with inferior batteries, we are meant to think) are running out of battery and we see a man run across a bridge-like corridor between two buildings. Cheerfully, but needing help, he shouts: I'm dying!

After the election, the poet Gerry Potter makes a video for social media. Gerry says: Their manifesto was a suicide note and 13 million of you signed it.

Gerry says: It's almost as if you don't want to live.

Jokes about the Chernobyl disaster, as reported by the LA Times on 18 May 1986:

Well, that thing on Gorbachev's head finally cleared up.

The Russians aren't much help for themselves, are they? Between two and two thousand people dead? You can see the guy building their reactor: Is that 6¾ inches or 5 feet, Boris? Oh, if there's a crack, just throw some caulking in there. A little stucco should do it, Boris.

Nothing but glowing reports from Moscow.

white bath

Hung-over but awake I find myself imagining a narrow, high-arched tunnel under a freestanding white bath. It is just wide enough to fit into on my side and for a moment I am imagining pulling myself into it, the sides closing in around me. I imagine how likely it is that although I can get myself in, I might become stuck in the middle. I would have to be cut free.

I am thinking of the only photograph I have of myself and my father, sitting in McDonald's. We are both holding strawberry milkshakes at the same angle, my father sucking thoughtfully on his straw.

Why do you want to go to Chernobyl? my mother asked me. It was such a long time ago.

Memories of sleeping in the back of the car, my father driving, on a motorway after dark.

A little girl and a little boy are in the elevator from the Tube at Belsize Park wearing school uniforms. The little girl has the fingers of one hand hidden by the other hand so that it's only the ends of two pink fingers that are poking out and several times she informs the little boy, in a casual manner: Two cherries.

Two cherries, she says, but where's the stem?

I went to the Chernobyl Exclusion Zone across the modern border from Ukraine in Belarus in early December 2019, after a chance conversation on WhatsApp I had with a friend while I was standing on an Underground platform. I started getting an urgent feeling around late November, worrying about how expensive tours were. I felt I had to go and look.

I saw the power station on the horizon from a fire observation tower. The tower was very high and I could see through the steps towards the ground and I was frightened. I saw the New Safe Confinement, white-blue on the horizon and the small rectangles of the other reactor buildings and grey-white off to the right I saw the Duga radar array. It was an extraordinarily beautiful day and we were more or less the only people in the Zone.

The cold had brought wild bison to a feeding area in the forest and we watched them, as if they were animals in a zoo, for half an hour, though we were on the inside of the fence, the bison outside.

a feed mill

I am walking in the ruins of a feed mill, not far from
Babchin in the Polesie State Radioecological Reserve;
the mill was once the largest agricultural enterprise in
the Khoynitsky region, milling food for livestock. The
quality of the light on this cold, early December morning
is astonishing and the tall dead grass and rushes outside
are golden-white under a perfect blue sky. The main hall
of the building is filled from ceiling to mid-height with
rusted steel industrial hoppers, many times my size. The
windows are missing, framing strange open views of
the lit field outside like pictures in a gallery, giving me a
confusing sense of looking in at the exterior.

I have never seen anything like this ruined factory, so peopled with things, and my brain decides we are looking at art.

I think I am thinking of Torqued Ellipses, a group of enormous sculptures made of russet weatherproof steel by Richard Serra, which I once saw at the Dia:Beacon gallery in upstate New York. Another of Serra's works, called Fulcrum (which is seventeen metres high), was installed at the western entrance of London's Liverpool Street Station in 1987 and I used to pass it quite a lot. Serra's sculptures are meant to be examined in motion, says a page I've downloaded, forcing the viewer to become a wanderer.

I am listening to a lecture by the artist Ann Hamilton. She says, My first hand is a sewing hand. She talks about cloth that, like the body, is always both an inside and an outside, a container and a contained.

She says: I hadn't thought a lot about sculpture, its issues of mass, weight, monumentality; the figure, the pedestal, the site. I arrived in sculpture for the fact of being a body, my experience as a body. I arrived in sculpture because I understood sculpture as the body in relationship, between ourselves and things. And making is the long return to this first hand.

In the presence of large sculptures like Fulcrum or B of the Bang, I am a child again, looking; the adult world is on an other scale.

Later that day, upstairs in the derelict secondary school at Pogonnoye, my guide, whose name is Peter, is joking that a small room with heavy steel bars at its entrance is a prison for bad children. I go inside, and to the left in the darkness there are two white urinals, child-sized, filthy, low down on the wall, and ahead is a large, deep metal locker, like a safe. At the height of the Cold War, he explains, it was decided that every child in the USSR should learn how to fire a Kalashnikov rifle, and this toilet was converted into a gun closet.

Try shooting radiation.

I realised something when I went to the Zone: when
I looked at all the mess and chaos on the floor in
photographs of buildings abandoned in the wake of
Chernobyl, with here and there an abandoned toy or
Soviet relic, I'd assumed it was just the work of nature
and time – or, in a more irrational way, the result of
a blast wave, as if the exploding reactor had scattered
everything in its wake, like the earthquake at Fukushima
or a hurricane.

What I was actually looking at in those pictures – this
may be obvious to you – was a place that has been
smashed up: not by a nuclear blast, but by people who
went there in the years after the disaster, and who were
poor and angry, maybe drunk, and violent and bored, the
people who took what they thought might be valuable,
stripped out precious metals and sold them on.

I've looked at those pictures before and thought: I am looking at the work of time; time destroys all things.

Time does destroy all things, it destroys nuclear waste eventually, and it's mainly time and nature that destroys the ceilings and the walls of those abandoned buildings, but poverty does it to people faster.

Poverty causes more cancer than fallout does.

As I am reading back the page on the photographs two pages back I notice the word: wake.

In its wake.

A funeral has a wake.

Awake.

Driving towards the edge of the Zone at the end of the day, but still on the restricted side of the barrier, we pass a small truck which has driven off the road and is parked in the grass to one side. Our van stops and the driver gets out.

The driver wakes up an old man who is sleeping in the truck and there is a loud, mainly one-sided conversation during which the old man reacts slowly and it is unclear if he is being reprimanded or not. The old man has produced a crumpled white paper bag and, after fishing around inside it, takes out what looks like a small lightbulb for a car headlight and gives it to the driver, who gets back in our van. We drive off and I ask my guide what has happened but he doesn't reply.

Poor Peter, talking to me all day about Chernobyl and your beautiful country and all I write about is lightbulbs.

After Belarus I go back to London and James has left
the corner of the duvet folded down and a note saying,
Welcome Home! See you later.

I light a candle in the corner of the bath and I put on
some music. Pink Floyd are singing Shine On You Crazy
Diamond, about their bandmate Syd Barrett who had
a nervous breakdown from which he never, if there are
right words for any of this, entirely recovered. Sax fills
the house.

On YouTube, as the music plays the video shows versions
of the album cover image by Storm Thorgerson: two
men, sunlight filling the street which seems to ascend a
steep incline. In front of the men there is the metal grate
of a drain. It is the Warner Bros back lot, which has sound
stages on both sides. On either side of the street there are
large white buildings with curving roofs and high doors.
The men are dressed in light-coloured business suits.
They look one another in the eye as they shake hands.

One of them is on fire.

While I was writing this in the bedroom, the bath has emptied again. The base of the bath carries the last traces of the water, it shines in the light like wet sand.

That album's called Wish You Were Here.

boeuf bourguignon

Early on New Year's Eve I am watching the romantic comedy Julie and Julia, about the American chef Julia Child and about Julie Powell who is thirty and works in New York taking calls from survivors of the 11 September attacks and who sets out to find herself through blogging about cooking Child's recipes in her tiny kitchen. Now and again in the exterior shots there are the red-and-white chimneys of the Ravenswood Generating Station, Long Island, New York.

Julie in Julie and Julia is talking about being eight years old and Julie's father's boss came to dinner and it was a really big deal: her mother made Julia Child's boeuf bourguignon (she pronounces it boof), and it was like she was there, she says, like Julia was there, in the room, on our side like some great, big, good fairy. I am embarrassed to write that I am thinking of the New Safe Confinement enclosing the Shelter Object at Chernobyl, on the horizon from the fire tower in Belarus – this great, big, awful thing (what must you think of me?) here, in the room, and on my side of what?

Do it to Julia! Not me! screams John Hurt in Room 101. John Hurt from Alien, Hurt who played Quentin Crisp in The Naked Civil Servant, John Hurt the voice of Monolith, the tombstone film about AIDS.

Julia, described first as the girl with dark hair, is the lover of repressed, tragic Winston Smith in Orwell's novel 1984. When they go out into nature, what Winston describes as the Golden Country, something flows.

Driving with my mother to the station one Tuesday afternoon, I am talking to her about antidepressant medication: the things it allows and the things it cuts off. She says lithium certainly saved my father.

I wonder if it might have saved his life.

My mother says: Your father was never suicidal, he always had me.

He killed you instead, I say.

She replies: Yes.

I am suddenly reminded of that last page about John Hurt in Room 101 – Do it to Julia! Not me! – and for a moment the link between these two things is unbearable and I am crying in the car.

My mother comforts me.

She says: It's all right, you must be overtired.

What can I tell you, about the world right now? That the plane is crashing, there has been an explosion, no one is driving the train? During the day I speak to people whose stories are marvellous to me and these are people who consider hanging themselves by rivers and they cut themselves just to vent something they can't put into words and they say something like, Yesterday I was looking at the sun on the tall blocks of flats not far off and I looked at how high they were and I thought wouldn't it be beautiful to jump, wouldn't that be amazing, I would fly and then all of the pain would be gone just like that and it would be so peaceful.

About eight weeks into lockdown my mother asked a decorator to come in to repaint the bathroom and the downstairs toilet and five days later we had a horrendous row. I'd cancelled my therapy because I thought the man on the other side of the wall might listen to all the nonsense I was talking. One morning she came in and said he needed to repaint the wardrobes in my bedroom. The next afternoon she asked when I was going to move all the piles of books off my bedside table, and off the top of the chest of drawers.

My mother was right, probably, that everything was a
mess and I was being an idiot wanting time and space
and being precious about it. I called James later on that
day, saying I was going to have to leave, that she'd told
me if I left not to bother coming back and James, who
was probably thinking, Oh God, well I don't want you
here either if you're going to be like that, was very calm
and said I ought to speak to her and that shouting was
never OK. I had shouted a lot; I feel bad about it now.
My mother still shouts the way she shouted at my father
when I was a child, watching, but she gets tired now and
says she can't take it any more, that she's seventy, it's too
hot, she has to sit down.

I was trying to get to the books she wanted me to move
to put them on the floor and she was blocking my
way, saying the floor couldn't take it, the ceiling would
collapse, and I was so angry, I had so little space, I shouted
and she shouted and I know that it's at moments like
these when a mist comes, and people murder people.
After the argument she told me she thinks it's not my
fault, that I'm probably autistic or bipolar. Maybe there's
something to it.

Speaking for a long time after the argument, my mother said that by the time he died she had hated my father, and that when he died it came as a relief. I guess it was a relief for me too, in a way. When I get angry like I did that afternoon the saddest thing is how when we get to a certain point of me trying not to shout and to explain and make her listen I know that she's not listening in the way I need her to listen and for her it's just like having my dad back in the house, trying to control things, teasing and bullying and saying, no, he's not lying, looking her in the eyes, absolutely not, and lying every time. And yet he paid for everything, grudgingly, but he kept working. He was very kind to a friend of mine once, said something very calming out of nowhere to her by the car after she'd had a bad break-up. I tore the arse of my pyjamas one morning, about a year before he died, and my father sewed it up perfect in a few minutes, just like that. I was looking at them this morning, actually, his line of white stitches. It's beautiful, really. They've held.

Halfway through drinking a cup of coffee before a patient arrives I am in the kitchen and Stevie Nicks is singing Sara from the Tusk album. I raise my arms outwards and above my head for ten or twenty seconds and I feel the music move me like a warm, strong wind. There are tears in my eyes. She is comparing someone who moves her very strongly to the wing of an enormous dark bird in a storm, a storm which itself has wings somehow, and about an unnamed man who is singing while he unlaces something which is never described. What is he unlacing the laces of – shoes? Boots? Underwear?

That's what it means, you know, analysis: unloosening, undoing.

It is towards the end of the film Ghost Dance and the
woman with dark hair is carrying rolled-up posters and
images towards the sea, and you can see the sea, just the
white flat edge of the seawater and you can hear the hiss
of white seafoam where the sea meets the shore. She is
packing mud around photographs of Marx and Derrida,
fixing them in place, and all the time there is this high
television static of water arriving at the shore line, of
waves breaking and we cut to an enormous messy wave,
all this black-and-white, and we cut to mud and to images
in the mud which we realise is the muddy cliff of the
beach. The camera moves outwards and it's colour and
the woman is noisily heaping shale from a half-kneeling
position over and across a huge black-and-white poster
of people and she's half-kneeling looking out towards the
breaking waves.

Now she has her back to the waves and she's dragging
towards the sea the poster which is tied up with a sort
of net of dark straps, and it's leaving two more or less
straight lines in the sand like she's wheeling it on a cart,
slightly downhill down the shale beach towards the
waves. She has dropped the poster now into the white
part where it's just flat foaming water and the waves
behind look fast and dangerous and high. We're close in
on the remains of the poster now and it is taken by the
sea and we can see it's on a kind of sled made of dark
branches, floating there. The sea is really enormously
loud.

A friend messages replying to my message about the film
Midnight Cowboy which I've been enjoying tonight but
can only watch in little bits, and it's hard reading this
back under lockdown, thinking of Ratso, Rizzo, Rico, dead
of pneumonia on the coach arriving at Miami and the
ocean and there is Toots Thielemans on the harmonica
and it kills me every time. The driver says to John Voight:
Is he kin to you? Wanna close his eyes? Reach over and
close his eyes.

The poster has formed a peak in its centre as it moves
back and forth in the flat water in front of the violet
waves like the sail of a jellyfish or a paper iceberg and the
dark of the water is black like oil. It's gone now, mixed up
somewhere in the loudness of the white wave foam and
the black water and this strange electronic music begins
like double bass or bass guitar and kazoo or tissue paper
on a comb and it fades to black. That's it, that's the end of
the film.

I am in the bath and downstairs my mother is playing
Abba's Money, Money, Money on her CD player.

Ah! My mother is singing.

And one day, but not today, we will go to the shore of the
sea, with the small plastic container of my father's ashes,
and as my mother stands some distance from the water
I will stand in the shallows with my trousers rolled up
and I will bend down, and gently pour my father into the
water.

My father's ashes will hang there reflecting the sunlight
in the salt water and some of him will sink to the bottom
and some of him will be taken by the sea. And we'll go
home.

Acknowledgements

Jessa says, it takes a village to raise a child. Some thanks:
Richard Porter and Pilot Press. My agent, John Ash. At
Faber, Emmie Francis. Sam Matthews. Brilliant readers
who helped this find a voice: Ali Smith, Olivia Laing,
Katherine Angel, Alice Goodman; Mark Belcher, Huw
Lemmey, Helen Macdonald, Jessa Leff. My partner,
James Upsher. My mother. Finn Ross, Adam Young and
Ash Woodward for commissioning two short pieces
for the Science Museum and Bletchley Park; Amanda
Lawrence. Patrick Cash and Spoken Word London.
Stephen Gee, my therapist. My supervisors and teachers
at The Site for Contemporary Psychoanalysis: Chris
Oakley, Eric Harper, Barbara Cawdron, Haya Oakley,
James Mann (Stephen again), Peter Nevins, Douglas Gill,
Tom Bradshaw, Kate Gilbert and Liz Guild. Christopher
Scanlon. My supervision group at SHP: Claudia and
Silvia. My training group at The Site: Scott, Jessa, Yael,
Spencer, Duncan, João, Baran, Katy, Katia, Laura, all of
you really. In the North: Ian Parker and Jason Scott,
Gerry Potter, Tracey Walsh and all at the New York New
York. In South London (to begin with): Stephen at Urban
Botanica, Stevie Purcell; The Royal Vauxhall Tavern,
Pam, Thom Shaw, Holly Revell, Travis Alabanza, Lasana
Shabazz, Shon Faye, Caspar Heinemann, Darren Evans,
Lysander Dove, Ebony Rose Dark. Sandra. Sam Webster,

Mike Fauconnier-Bank, Sam Jones, Jess Brammar, Jim Waterson, Alexa and Prashant, Tina, Richard Hackney and Thomas Kendall, Thomas Hale, James Williams, Emma Woolerton, James Butler. Philip Venables, Timothy Thornton. Janet Fischgrund, Sascha, Jeanette and all at Rick Owens, London, Michèle Lamy, Penny Arcade, The Wooster Group, Paul and Christeene, Veda, Justin Vivian Bond. My students. My patients. My father. Although a mostly invisible presence in this book, I owe a great debt to David Hoyle, who once stood at a bus stop wearing Bikini Atoll earrings: a radioactive artist with more to say about our age than we can bear to hear.

Translations are mine unless otherwise attributed, as is responsibility for any errors.

This book was written at a time where YouTube was open access and items with small viewer ratings often played without adverts. As this is a landscape in transition, and copyright holders are likely to become more rather than less concerned as to which social media uploads count as fair use, I have not included YouTube, Twitter or Facebook links in these notes.

MELTDOWN

v *I don't . . . about?* Svetlana Alexievich, *Chernobyl Prayer: Voices from Chernobyl*, trans. Anna Gunin and Arch Tait, Penguin, 2016

3 *It's fine . . . allowed* *Red*, dir. Robert Schwentke, 2010

4 *without its flow* Denise Riley, *Time Lived, Without Its Flow*, Picador, 2019

7 *We're . . . fierce* *Paris Is Burning*, dir. Jennie Livingston, 1990

10 *Nothing in life . . . understood* Dan Nosowitz, 'The Woman Who Ate Chernobyl's Apples', *Atlas Obscura*, April 2015, https:// www.atlasobscura.com/articles/the-woman-who-ate-chernobyl-s-apples. Quotation attributed to Marie Curie in the epigraph of Melvin A. Benarde, *Our Precarious Habitat*, Norton, 1970

19 *She's up . . . not a romance* Victoria Wood, 'A Modern Romance', dir. Alasdair MacMillan, ITV, 1991; lyrics appear by kind permission of the Victoria Wood Estate

21 *Timothy Snyder says* Timothy Snyder, *The Road to Unfreedom*, Bodley Head, 2018

22 *She's bought . . . romance* Victoria Wood, 'A Modern Romance'

23 *I have lick'd . . . very purplue* John Keats, 'To Fanny Brawne, (?)
Feb. 1820' [Harvard MS] in *Selected Letters*, ed. John Barnard,
Penguin, 2014, p. 501; Keats crossed out the final two letters of
'purplue'

30 *without memory or desire* Wilfred Ruprecht Bion, *Attention
and Interpretation*, Basic Books, 1970

30 *I had not . . . reason* John Keats, 'To George and Tom Keats, 21,
27 (?) Dec. 1817' [Jeffrey transcript, 1845] in *Selected Letters*

36 *All through . . . romance* Victoria Wood, 'A Modern Romance'

42 *On a rock . . . going down* John Berger, 'Past Present', *Guardian*,
12 Oct. 2002

43 *Cro-Magnon painting . . . carries* John Berger, 'Past Present'

44 *Here the brush-stroke . . . fill it in; mysterious because . . . fresh
gain* Francis Bacon, in *Matthew Smith: Paintings 1909–1952*,
Tate, 1953

70 *For all things . . . like a bowl* Zosimos of Panopolis, trans. F.
Sherwood Taylor, 'The Visions of Zosimos', *Ambix* 1, 1, May
1937, pp. 88–92

73 *you are not sure . . . darker* Franz Kafka, 'Vor dem Gesetz': this
short parable appears in several versions, the first printed in the
independent Jewish weekly *Selbstwehr* [Self-defence], 1915; *Ein
Landarzt* [A Country Doctor], Kurt Wolff, 1919, and in Franz
Kafka, *Der Process* [The Trial], Verlag Die Schmiede, 1925

74 *A man . . . stronger than me* Franz Kafka, 'Vor dem Gesetz'

75 *Eventually he grows old . . . going to shut it* 'Vor dem Gesetz'

77 *In New Zealand . . . shark* story adapted from Ira Glass and Anon.,
'Just Keep Breathing', *This American Life* (476), 5 Oct. 2012: Glass
uses the phrase 'increasingly difficult for her to breathe'

84 *th' expense . . . shame* William Shakespeare, Sonnet 129

97 *Noli me tangere . . . tame* Thomas Wyatt, 'Whoso list to hunt'

101 *until . . . disassembled itself* 'Chernobyl disaster', Wikipedia

104 *Oh don't do that! Don't do that!* 'Horror of Fang Rock' (episode
1), *Doctor Who*, dir. Paddy Russell, BBC, 1977

123 *She herself is a haunted house* Angela Carter, 'The Lady of the
House of Love' in *Burning Your Boats*, Vintage, 1995

129 *He's stroking . . . shines* Victoria Wood, 'A Modern Romance'

135 *Of course some . . . my own* Quentin Crisp, in *World in Action*, dir. Denis Mitchell, 1971

139 *And as the bus . . . I can* Quentin Crisp, *World in Action*

HEJIRA

144 *Jesus . . . burned and blistered* The Line, the Cross and the Curve, dir. Kate Bush, 1993

145 *There was . . . get back* The Line, the Cross and the Curve

145 *something . . . your kindness* The Line, the Cross and the Curve

147 *Once upon a time . . . grow quite red* Hans Christian Andersen, 'De røde sko' in *Nye Eventyr: Første Bind: Tredie Samling*, C. A. Reitzel, 1845; Andersen's text goes further than my translation: 'so that her little instep grew quite red and it looked horrible'

148 *In the middle . . . simple coffin* Andersen, 'De røde sko'

150 *but the dead . . . than dance* Andersen, 'De røde sko':

153 *chickachickchickchickchick . . . Big Sur, right?* Rolling Thunder Revue: A Bob Dylan Story, dir. Martin Scorsese, 2019

154 *William Zanzinger . . . fuck you up* Rolling Thunder Revue

157 *A very long . . . way to heaven* Compare Genesis 11:1–9

158 *Well, I don't think . . . English language* 'Words + Music – Joni Mitchell and Morrissey', Reprise Records, 1996; an edited version appeared in *Rolling Stone*, March 1997

159 *It is said . . . they shrugged* Pirkei deRabbi Eliezer 24; I am grateful to Alice Goodman for (amongst very many other things) the reference and her translation

164 *Al-kīmiyā* 'Alchemy', Wikipedia

168 *There once was a mouse . . . very clean now!* Arnold Lobel, 'The Bath', *Mouse Tales*, HarperCollins, 1972

178 *The dead . . . hot stove; Like them . . . soft body* Robin Beth Schaer, 'Holdfast', Poem-a-Day, Academy of American Poets, Spring 2019; quoted by kind permission of Robin Beth Schaer

179 *It happened . . . my mother's hand . . . carried me away* Joel-Peter Witkin in Jeanne Storck, 'Band of Outsiders:

Williamsburg's Renegade Artists', billburg.com, 2001

181 *I had worried . . . I'm glad* Erin O'Connor, 'Subjective: Erin O'Connor interviewed by Nick Knight about Alexander McQueen S/S 01', SHOWStudio, (2014)

185 *This living hand . . . towards you* John Keats, written in the margin of Keats' manuscript of 'The Cap and Bells', *c.*1819, see John Keats, *Complete Poems*, Modern Library, 1994

186 *Making sense . . . Lacan's;* Jacques-Alain Miller, 'Ordinary Psychosis Revisited' in *Psychoanalytical Notebooks 19*, ed. Natalie Wülfing, text transcribed and established by Adrian Price, London Society of the NLS, 2008

187 *In practice . . . sense of things* Miller, 'Ordinary Psychosis'

192 *Clouds gather visibility . . . clouds* John Berger, 'On Visibility' in *The White Bird*, Chatto & Windus, 1985

193 *Nationalism . . . cannot be refused* Jeanette Winterson, *Frankissstein*, Vintage, 2019

193 *We are air, we are not earth* Merab Mamardashvili, epigraph to Svetlana Alexievich, *Chernobyl Prayer: Voices from Chernobyl*, trans. Anna Gunin and Arch Tait, Penguin, 2016

195 *Usually the music . . . craving as a story?* Joni Mitchell interviewed by Jian Ghomeshi for CBC, 2013; 'craving' has elsewhere been transcribed as 'creating'

208 *I love Hollywood . . . to be plastic* Andy Warhol 'I love Los Angeles, and I love Hollywood. They're beautiful. Everybody's plastic, but I love plastic. I want to be plastic' [The Stockholm Catalogue] Published on the occasion of the Andy Warhol exhibition at Moderna Museet in Stockholm, February–March 1968, Moderna Museet, 1968

214 *84% . . . landfill* Alden Wicken, 'Fast Fashion is Creating an Environmental Crisis', *Newsweek*, 2016; in 2018 'the UK sent 300,000 tonnes of clothing waste to be burned or dumped in landfill': Catherine Early, 'The UK fashion sector is already on trend to miss 2020 waste targets', *Greenbiz*, 2018

216 *I would like . . . into being* Jack Spicer, *After Lorca*, White Rabbit Press, 1957. This edition: NYRB, 2021

221 *Owl felt sorry for winter . . . hard, green ice* Arnold Lobel, 'The Guest', *Owl at Home*, HarperCollins, 1975

228 *A person is rubbish . . . another realm* Joel-Peter Witkin, 'Joel-Peter Witkin, Interview' - Hamiltons Gallery, London 1990

231 *Joni sings . . . it hurts* Joni Mitchell, 'Lakota', *Chalk Mark in a Rain Storm*, Geffen, 1978

233 *Joel-Peter Witkin . . . Jimmy* Interview: Joel-Peter Witkin, artnet, 2011. Witkin: 'What kind of conditioning is this? [. . .] It wasn't until years and years later that the moral aspect of that hit me.'

234 *All this whiteness . . . to ashes* Frantz Fanon, *Peau noir masques blancs* [*Black Skin White Masks*], Éditions du seuil, 1952

235 *Still many people . . . events* Information film English subtitles, TEPCO Decommissioning Information Centre, Tomioka, 2019

237 *Witkin's hospital sweepings . . . at all* Vicki Goldberg in *Joel-Peter Witkin: An Objective Eye*, dir. Thomas Marino, 2013

238 *The dramatic . . . poem of the earth* Rachel Carson, *The Sea Around Us*, Oxford University Press, 1951

239 *love is boundless as the sea* Rachel Carson, *Always, Rachel: the Letters of Rachel Carson and Dorothy Freeman 1952–1964: The Story of a Remarkable Friendship*, Beacon Press, 1996

241 *I was ever so cold, my whole family* 'The Endowment', *Ivor the Engine*, dir. Oliver Postgate, ITV, 1976

245 *Columbus didn't discover . . . storm* *Rolling Thunder Revue*

246 *Men, all men . . . blondes* Joni Mitchell, interview 2013

247 *We act not just . . . all mankind* *Rolling Thunder Revue*

247 *And the archer . . . real private* *Rolling Thunder Revue*

250 *spit in the eye* *Rolling Thunder Revue*

255 *Life isn't about . . . creating things* *Rolling Thunder Revue*

DELIVERANCE

263 *I used to . . . see it again* They Shoot Horses, Don't They? dir. Sydney Pollack, 1969

263 *Here they are . . . can they last?* They Shoot Horses, Don't They?

264 *You want . . . the river* Deliverance, dir. John Boorman, 1972

267 *I thought it will never . . . my life!* Ma Anand Sheela, *Wild Wild Country*, dir. Maclain and Chapman Way, 2018

269 *a long article . . . Wild Wild Country* Win McCormack, 'Outside the Limits of the Human Imagination', *The New Republic*, March 27, 2018

270 *It seemed like ages . . . shoot him* John Crilly in Clive Colman, 'London Bridge attack: Reformed prisoner who fought knifeman "prepared to die"', BBC News, 12 Dec. 2019

271 *There was . . . Chernobyl* Chernobyl, dir. John Renck, 2019

271 *I know you perfectly well . . . a fishmonger* William Shakespeare, *Hamlet*, 2.2

272 *Daddy, can't I . . . pretty white dress* Kathy Acker, *Desire*, 1982

274 *What is painted . . . this shelter* John Berger 'The Place of Painting', *The White Bird*

276 *There is a moment . . . clean him up* Derek Jarman, *Smiling in Slow Motion*, Vintage, 2001

279 *When two people . . . known beside us* Ghost Dance, dir. Ken McMullen, 1983

280 *I believe that ghosts . . . even yours!* Jacques Derrida in *Ghost Dance*, dir. Ken McMullen, original subtitles trans. Peter Dews, Chaton Houette

282 *Whoso list . . . cometh behind* Thomas Wyatt, *Complete Poems*, ed. by R. A. Rebholz, Penguin, 2015

282 *Through narration . . . wreak* Antonino Ferro, 'Spatial and Narrative Container', Virtual Psychoanalytic Museum, 2015

283 *But . . . (Cancelled.)* The Seventh Seal, dir. Ingmar Bergman, 1957

284 *The . . . cheeks; Mia . . . dreams* The Seventh Seal

285 *Oh it's . . . milk* The Seventh Seal

286 *I had dibs, says Neal . . . Arh! Arh!* 'BoJack Hates the Troops', *BoJack Horseman*, dir. J. C. Gonzalez, 2014

287 *Mother, give me . . . sun* Henrik Ibsen, *Gengangere: et familje-drama i tre akter Gyldendal* [*Ghosts*] (F. Hegel & Søn), 1881

291 *Dalí's Persistence of Memory . . . nightmare world; Horrible painting* Sister Wendy Beckett, *Sister Wendy Beckett's Story of Painting*, prod. Emma De'Ath, 1996

293 *Why doesn't ... born?* W. H. Auden and Christopher
 Isherwood, *Ascent of F6*, Faber, 1936; this edition, 1986

296 *I grew up ... a shock; I went to ... knew our place* Alan Garner:
 All Systems Go!, dir. Lawrence Moore, 1973

297 *The sandstone ... equator; It's still ... go with it* Alan Garner:
 All Systems Go!

299 *His memory of sneaking ... violently wise* Ali Smith, 'History
 of Violence', New Statesman, 9 May 2016

300 *It was like having ... pretty disgusting* Wendy Davenport, in
 Auschwitz: The Nazis and the Final Solution, dir. Laurence Rees
 and Catherine Tatge, 2005

302 *Waving and ... England* Barbara Newman, in *Auschwitz*

304 *Nature ... beloved child* Adolf Hitler, *Mein Kampf*,
 Zentralverlag der NSDAP, 1939, p. 140; trans. Hans-Heinrich
 Nolte in 'Stalinism as Total Social War' in Roger Chickening
 and Stig Forster (eds), *The Shadows of Total War*, Cambridge
 University Press, 2013, p. 308

305 *ghosts are our shadows* See for example Carl Jung, *Aion* (1951),
 in *The Collected Works of Carl Jung*, vol. 9.2, ed. by Herbert Read
 et al., trans. R. F. L. Hull, Routledge, 2014, pp. 8–10.

316 *It's like in ... they understand* 'Vasiliy Lomachenko talks
 Luke Campbell fight, dream fight vs. Floyd Mayweather',
 ESPN, 2019

317 *It's three years ... the Independent* Derek Jarman, *Modern
 Nature*, Vintage, 1992

317 *Deep in the night ... that for?* Derek Jarman, *Modern Nature*

318 *I took my Super 8 ... tea and scones* Derek Jarman, *Kicking the
 Pricks*, Vintage, 1996

319 *In the summer ... radiant smile; My father ... 1953* Derek
 Jarman, *Kicking The Pricks*, 1996

320 *he sailed ... dismantling cars* Jarman, *Kicking The Pricks*

321 *It was a disaster ... people* Derek Jarman, interview by Anthony
 Clare, *In the Psychiatrist's Chair*, William Heinemann Ltd, 1992

322 *HB true love* Derek Jarman, *Smiling in Slow Motion*, Vintage, 2001

323 *They say the ice age is coming ... Look! Johnny look! The*

Last of England, dir. Derek Jarman, 1987

325 *The nuclear . . . dark clouds* Derek Jarman, *Modern Nature*

326 *Mist drifts . . . in the garden; Long walk . . . angry slate sky* Derek Jarman, *Modern Nature*

327 *and all I feel is pressure* David Wojnarowicz, reading a text he incorporated into the painting 'Untitled (Hujar Dead)', *c.*1988–9

327 *dead good-looking . . . summer Blue*, dir. Derek Jarman, 1993

327 *Fuck me blind* Derek Jarman, *Fuck me blind* [oil on canvas], 1993

329 *Hold it . . . you're all right Billy Elliot*, dir. Stephen Daldry, 2000

329 *Terror . . . each other* Hannah Arendt, *The Origins of Totalitarianism*, Schocken Books, 1951

330 *Eve Libertine . . . horror* Crass, 'Asylum', *The Feeding of the 5000*, 1978; Eve Libertine is reading from Penny Rimbaud and Eve Libertine, *Christ's Reality Asylum and Les Pommes de Printemps*, Exitstencil Press, 1977

330 *when I'm dancing, I sort of disappear Billy Elliot*

336 *When our eyes met . . . compelled to follow him* Arthur Chichester, *The Burning Edge: Travels Through Irradiated Belarus*, Robacuna, 2018

338 *I think . . . different things* Ian Curtis, interview for BBC Radio Blackburn by Steve Barker, recorded 28 Feb. 1980

338 *your bedroom . . . Love Will Tear Us Apart So This Is Permanence*, ed. Deborah Curtis and Jon Savage, Faber, 1988

339 *I didn't understand . . . up for discussion* Deborah Curtis, 'Foreword' to *So This Is Permanence*, pp. vii–xi, p. vii

341 *There were these . . . he really was* Genesis P. Orridge, *Joy Division*, dir. Grant Gee, 2007

341 *We started out . . . didn't expect* Genesis P. Orridge, *The Ballad of Genesis and Lady Jaye*, dir. Marie Losier, 2011

344 *To talk of life . . . can anyone take?* Jon Savage, 'Joy Division's *Unknown Pleasures* review', *Melody Maker*, 21 July 1979

345 *It was a completely pure . . . his letters* Annik Honoré, in *Joy Division*, dir. Grant Gee

346 *You know he was . . . His burning eyes* Annik Honoré, in *Joy Division*, dir. Grant Gee

346 *a page of phrases* context.reverso.net

350 *another story about a nuclear accident* The Radiological accident
 in Goiânia, International Atomic Energy Agency, 1988; 'The
 Goiânia Incident', *Disaster*, dir. Kim Flitcroft, BBC, 1997

354 *When I was young . . . chronic invalid* This anecdote appears
 in Quentin's broadcasts with various slight variations and was
 published as, Quentin Crisp, *How to Become a Virgin*, Quality
 Paperback Book Club, 2000, p. 218

360 *You push . . . find anything* Deliverance

361 *The more rapidly . . . it seems* Kathy Acker, *Desire*, 1982

362 *Something's wrong; Right there's . . . this town* Deliverance

368 *I think your friend has gone really mad* Sebastian Pons,
 McQueen, dir. Ian Bonhôte and Peter Ettedgui

370 *Well, that thing on . . . Moscow* Marison Mull and Christopher
 Tricarico, 'Chernobyl Jokes Mushroom', *LA Times*, 18 May 1986

376 *Serra's sculptures . . . a wanderer* 'Richard Serra: Torqued
 Ellipses', exhibition notes, Dia, https://www.diaart.org/
 exhibition/exhibitions-projects/richard-serra-exhibition

377 *My first . . . sewing hand; I hadn't thought . . . first hand* Ann
 Hamilton, in *The Event of a Thread*, prod. Ian Forster, 2013

385 *and it was like . . . fairy* Julie and Julia, dir. Nora Ephron, 2009

386 *Do it to Julia! Not me!* 1984, dir. Michael Radford, 1984

386 *the Golden Country* George Orwell, *Nineteen Eighty-Four*,
 Secker & Warburg, 1949

394 *Is he kin . . . eyes* Midnight Cowboy, dir. John Schlesinger, 1969